ELEPHANT HOUSE

[elephant

ANIMALIBUS VOL. 7
OF ANIMALS AND CULTURES

Nigel Rothfels and Garry Marvin,
GENERAL EDITORS

Advisory Board:
Steve Baker
(University of Central Lancashire)
Susan McHugh
(University of New England)
Jules Pretty
(University of Essex)
Alan Rauch *(University of North Carolina at Charlotte)*

Books in the Animalibus series share a fascination with the status and the role of animals in human life. Crossing the humanities and the social sciences to include work in history, anthropology, social and cultural geography, environmental studies, and literary and art criticism, these books ask what thinking about nonhuman animals can teach us about human cultures, about what it means to be human, and about how that meaning might shift across times and places.

house]

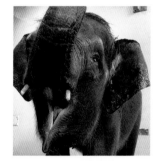

[CHENDRA]

THE PENNSYLVANIA
STATE UNIVERSITY
PRESS
UNIVERSITY PARK,
PENNSYLVANIA

DICK BLAU

AND

NIGEL ROTHFELS

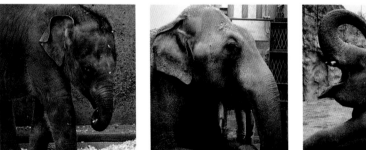

[LILY] [PACKY] [RAMA]

Library of Congress
Cataloging-in-Publication Data
Blau, Dick, 1943– , photographer.
Elephant house / Dick Blau and Nigel
Rothfels ; foreword, Mike Keele.
 pages cm
— (Animalibus)
Summary: "Traces the history of the
Asian elephant display at the Oregon
Zoo from the 1950s to the present.
An introduction by historian Nigel
Rothfels explores changes in ele-
phant husbandry since the 1870s"—
Provided by publisher.
Includes bibliographical references
and index.
ISBN 978-0-271-07085-8
(cloth : alk. paper)

1. Captive elephants—Oregon—
Portland—Pictorial works.
2. Oregon Zoo (Portland, Or.)—
Pictorial works.
3. Captive elephants—History.
I. Rothfels, Nigel, writer of
introduction. II. Title. III. Series:
Animalibus.

SF408.6.E44B53 2015
636.96709741'91—dc23
2015006593

Copyright © 2015
The Pennsylvania State University
All rights reserved
Printed in China by
Oceanic Graphic International
Published by The Pennsylvania
State University Press,
University Park, PA 16802–1003

The Pennsylvania State University
Press is a member of the Association
of American University Presses.

It is the policy of The Pennsylvania
State University Press to use
acid-free paper. Publications on
uncoated stock satisfy the minimum
requirements of American National
Standard for Information Sciences—
Permanence of Paper for Printed
Library Material, ANSI Z39.48–1992.

Designed by Regina Starace

[contents]

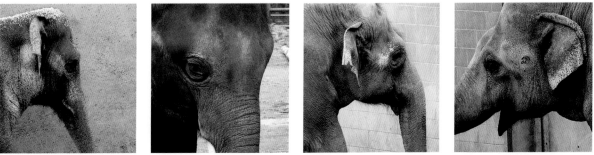

[ROSE-TU] [SAMUDRA] [SUNG-SURIN] [TUSKO]

[foreword] MIKE KEELE

When Nigel and Dick proposed this project to the Oregon Zoo, I was excited, as I saw this as an opportunity to tell the story of elephant care in a new but also historically accurate way. How have caring individuals been able to provide for the daily mental and physical needs of these magnificent animals while advocating for needed changes in the facilities, changes that have made it possible for care to improve over the years? So, to me, the story of this book is not simply about a state-of-the-art building that must eventually come down, but also about how caring individuals made that happen and how their work has resulted in a better future for the elephants. And this metamorphosis did not just happen at the Oregon Zoo; it happened at many U.S. zoos that care for elephants, each institution urged on by the advocacy of its own care personnel. These are extraordinary individuals who speak to and for the elephants.

I began my career at the Oregon Zoo in 1971 and began working full-time with the elephants in 1975. The zoo provided me with wonderful opportunities during my career, and foremost among them was my work with the elephants. When I started, the zoo had a family of nine elephants, and an elephant birth was a fairly

common event. Between 1962 and 1975, fifteen elephant calves were born in Portland, causing one local newscaster to wonder whether the zoo would name its most recent baby "Enough." What that reporter didn't realize was how rare zoo-born elephants were, as no other elephants had been born anywhere in North America but in Portland since 1918. I spent many nights at the elephant house, waiting for an expectant mother to deliver her calf. In retrospect, it wasn't that we needed to be there to assist the elephants with the birth, because by that point they were very experienced mothers. We were there, I know, because we wanted to witness the extraordinary event of the birth and see how the cows worked together to help the newborn, thereby creating even closer bonds among themselves. At times, the behavior seemed a bit frantic, but it wasn't: we were just witnessing excited elephants being elephants.

Part of the zoo's Asian elephant breeding success was due to the facilities that allowed for the safe management and care of adult bull elephants. Bulls are powerful and often aggressive, making them dangerous to work around. A six-ton elephant can really do a lot of damage to a facility that hasn't been engineered to withstand powerful ramming, a trunk that can reach great distances, and an animal capable of standing on its hind legs to "tinker" with light fixtures or ductwork. Portland's elephant barn addressed these challenges with a lot of concrete. This functional facility was never exactly aesthetically pleasing, yet as unaesthetic as it may have been, the building had its advantages. It allowed the elephants to free-range throughout the day *and* night, when elsewhere in the country it was necessary to chain the elephants overnight to prevent them from demolishing the buildings.

When I first worked with elephants, I quickly learned that each had a unique personality. I became friends with the females, and my favorite was Pet. Unlike the other cows in her herd, she was not competitive, choosing to be the lowest cow of the pecking order—a position that is also the least stressful. Pet and I developed our own greeting: she would come up to me and lower her head. I would rub and scratch the inside of her front leg, and she would put her ear out so that my head was behind it. I would then talk to her softly and scratch the back side of her ear while she lowered her head even more. We did this often; she seemed to like it, and I know I did.

Pet didn't like us to trim her feet. We guessed that someone had hurt her once. But I was patient and relied on our friendship, and eventually, I had Pet's full cooperation for foot trims. It was a trust issue; Pet trusted me to be gentle with her while I was caring for her feet. And treating her gently paid off by strengthening our friendship. When I was no longer a caregiver, I would visit the elephant barn and sometimes get to be with the elephants. Pet never forgot me. She would engage me in our greeting, and that would be a very special day for me. We had our final greeting one week before she died in 2006, but she left me with a lasting memory, and I hope her life was made easier by the improvements we made during her time with us. I would wager that almost all elephant caregivers have similar stories about animals they considered particularly special.

Several images in *Elephant House* capture moments between people and elephants that are both rewarding and challenging: rewarding, because at the end of the day you feel as though you've made a positive difference in the lives of the elephants in your care; challenging, because you always feel that there is more you can do. It is because we have been trying to do better over a very long time that an elephant facility that was "state of the art" over fifty years ago has undergone repeated changes and is now being closed. Over the years, the facility's footprint expanded twice; concrete and asphalt were replaced with natural substrate; concrete interior flooring was cushioned; dangerous moats

were removed; and an elephant squeeze chute was installed. That chute, which appears in some of these photographs, was the first of its kind in North America, and it allowed the zoo to provide much better and safer care for the bull elephants. All of the improvements I have listed were intended to improve the care of the elephants—not to improve the exhibit experience for the zoo visitor. The indoor spaces in the elephant barn function, as designed, to meet the care needs of the elephants, but these spaces can make zoo visitors today feel uncomfortable. That discomfort is part of the process of improving our facilities for the public and the animals. As our expectations for our facilities have changed over time, so too have the facilities. When I look at the images in this book, I see the facilities as they were when the pictures were taken, but I also see them in the ways they have changed over the years. I am proud that this zoo has such a strong tradition of ongoing improvement.

By the time this book comes out, the old elephant house will have been demolished, and a new complex for the elephants will have been opened. The new facilities are designed to make it possible for the elephants to make more choices about how they spend their day.

This will result in their activities being more elephant directed and less human directed. There will be more choices about social interaction, exercise, browsing, bathing, resting, and other activities. The new Elephant Lands exhibit incorporates all that we have learned over the years about caring for elephants, and much of that we learned from the old elephant house of this book.

I retired from the Oregon Zoo in 2014 after forty-two years. *Elephant House* is perhaps especially important to me because it serves as a sort of scrapbook, reminding me of all that has been done over the last fifty years to improve the care we provide for our elephants. For others, though, I hope that this book provides a little insight into the relationships between people and elephants that are at the heart of both this project and the elephant house itself. The old elephant house is gone now, but these images will always remind me of the privilege I had to work in this building with such extraordinary friends.

[elephant house] NIGEL ROTHFELS

By the early years of the twentieth century, every major city in Europe and the United States had either constructed a large municipal zoological garden or had ambitions to do so. As institutions designed to promote recreation, science, and education, if not yet conservation, zoological gardens at the time were built to reflect the values of an upper class hoping to appear beneficent and a middle class hoping to appear credible. Along with city art collections, orchestras, botanic gardens, natural history museums, sewage systems, streetcars, subways, and rail systems, zoological gardens signaled both the affluence and influence of the major cities and were part of the aspirational infrastructure of bourgeois culture. This was not only the case in Europe and the United States, moreover; the major colonial cities of the world, places that sought in many respects to emulate the metropoles, also had their zoos.

There is a tendency to think about these zoological gardens of long ago as somehow less complicated and fraught institutions than they are today. This is a misreading of both the past and the present. Popular images from the later decades of the nineteenth century at the London Zoo, for example, typically show idyllic

scenes of respectful couples strolling, small groups of young men or women talking animatedly, families with only one or two well-behaved children enjoying an educational outing, and animals in peak physical condition and calm temperament happily ignoring their own captivity. This was certainly the vision of the *proponents* of the zoo, but it remains a vision far removed from the reality of the actual institution. It is true that when it was conceived, this collection of living animals in Regent's Park was expected to be a tranquil reserve for the Zoological Society's Fellows and their guests, an institution devoted to the pursuit of science and elevated recreation. But within only a few years of its opening in 1828, this zoo's future (and indeed the future of every zoo built since) as an approved place of mass recreation for all but the lowest orders of urban society was abundantly clear. These institutions became places of amusement for an expanding urban public, and if rank animal houses, stagnant ponds, littered lawns, bawling children, less glamorously dressed, lewd, and otherwise obnoxious adults, and bored, sick, or depressed animals do not feature prominently in what were essentially promotional images of nineteenth-century zoos, it is really not all that surprising.

Nineteenth-century zoos also had their critics. While it is true that they were not as successful in getting their views heard as they might be today, there were clearly many people who were convinced that the animals suffered in zoos and who wondered out loud about the supposed educational and recreational appeal of institutions that often seemed to exhibit little more than the pathological behaviors of caged animals. When the first zoo to attempt to exhibit captive animals systematically, in naturalistic panoramas, opened in 1907, a place where the animals were separated from each other through concealed moats, it was a huge sensation precisely because people had become so uncomfortable looking at animals behind bars. What has become known as the Hagenbeck Revolution in zoo design—the moment when animals in zoos were "freed" from their cages—was the result of the animal dealer, circus entrepreneur, and zoo designer Carl Hagenbeck's attention to the discomfort of the people who had been visiting the allegedly idyllic zoological gardens of the nineteenth century.[1]

But if the circumstances of nineteenth-century zoos were far less bucolic than they are often remembered to have been, today's zoos are actually less contentious institutions than many seem to believe. Indeed, despite the fact that critics of zoos have been ringing the institutions' death knell for almost as long as they have existed, when I drive by the suburban zoo in my Midwestern U.S. city, I still see parking lots filled with the nicely ordered cars of the over 1.3 million zoo visitors every year, and this in a metropolitan area with barely as many residents. In the end, certain aspects of zoos don't seem to change very much over time. Consider the issue of feeding the animals. I can vividly remember the quickly moving, soft muzzles of the fallow deer at the zoo near where I grew up as the animals searched for pieces of popcorn in my outstretched hand. Of course, I recall this memory today with a measure of guilt because of the thought of how much popcorn, salt, and oils those deer must have consumed, with all the other children doing exactly what I was doing, but it seems that feeding has pretty much been central to our curiosity about exotic animals since we started keeping them in captivity. Most large zoos today try to control the activity, of course, but the fascination with feeding continues, and the prominent role of feeding in the daily programs of zoos will continue as well. Today, sometimes the feeder is an apparently randomly chosen representative of the audience—a young boy or girl holding a fish out to a rising dolphin, for example. Sometimes the feeder is a keeper sliding a tray of highly processed meat into an exhibit housing a seemingly unimpressed cat; sometimes

a closely monitored feeder pays extra to place a hay biscuit on the outstretched, twisting tongue of a giraffe; sometimes the feeder just pops a quarter into a machine and gets a handful of chow to throw to the dwarf goats. Of course, however much zoos try to meet the demand, it will not be enough and rules will be broken. Signs variously ordering "Do Not Feed the Animals" date back, in fact, to the very beginnings of zoological gardens. Indeed, signs regulating feeding were even present at the private aristocratic collections that existed before the public zoos. The point about these signs is that they exist *not* because people can be relied upon to follow clearly articulated rules, but precisely because they can't be! This was as much the case in the nineteenth century as it is today.

Nevertheless, as much as it might seem that the underlying challenges facing all zoos—controlling both ideas and animals—do not appear to change very much over time, it is also clear that the experience of visiting the more ambitious zoos of today, at least, is quite different from that experience a hundred years ago.[2] While it is often just hype when contemporary zoos announce plans for a revolutionary exhibit—a place where visitors will finally feel like neither the animals nor the visitors are actually in a zoo—the budgets, technology, and expertise behind contemporary exhibit design can and often do bring extraordinary and entirely new experiences to the public, and advances in animal care over recent decades have made zoos undeniably healthier and generally (if not uniformly) better places for animals as well.

I have started this essay with a few words about change and continuity in the world of zoos because this book is very much about both of these themes. The project began in a conversation between Dick Blau and me about elephants and photography. At the time, Dick was completing a project about labor in Wisconsin and, as part of that, had been photographing the activities of a large-animal veterinarian. At the same time, I was in the midst of research about how ideas about elephants have been changing over the last couple of hundred years. I wanted to collaborate with Dick because it seemed to me that over his career of working at the borders between anthropology and photography, he had found ways of helping us see important things about relationships. Whether focusing on such seemingly unrelated subjects as the domestic life of his family, the lives of Romani musicians in northern Greece, a Dionysus cult, the present of polka in the United States, or a veterinarian doing a tooth extraction on a fully awake horse, Dick had managed to capture important moments of physical, emotional, and other kinds of contact that we miss when we are glancing too quickly at life. I had been trying to make sense of the relationships I had been observing between zoo elephant keepers and the animals they cared for, and I hoped that working with Dick would help me in that process.

While it is not that difficult to stand outside of a relationship and *describe it* convincingly as being about love, power, abuse, sacrifice, or whatever, it is probably impossible to stand outside a relationship and *understand it* for all it is. We can never see the whole relationship, never comprehend it in all its dimensions. Describing a relationship between a person and an animal can be even more complicated, because although both creatures are eloquent, the animal's voice can often be more difficult to hear and understand. But it is precisely the relationships between the keepers and the elephants in zoos that we wanted to explore. The *relationships*, because they seemed remarkably hidden and yet we believed they would be important for people to learn more about; in *zoos*, because that is where most elephants in North America live and, in the context of animal-rights debates, zoos seem to occupy a middle, somewhat neutral ground for most people.

So much of the debate about whether or where elephants should be held in captivity—in what are generally called zoos, circuses, or sanctuaries—turns on claims that this or that facility or staff is better able to meet the needs of the animal, and that the animal, in the end, will be happiest there. This is not the place for a full description of the competing claims made by advocates for these various settings. Suffice it to say that there are about three hundred elephants living today in North America. A very small number are cared for in a variety of places called "sanctuaries"; a larger number are cared for in commercial settings, including, but not exclusively, in "circuses"; and most are cared for in institutions called "zoological gardens," themselves quite different from one another. Frequently, people quickly note that elephants are kept in zoos, circuses, and sanctuaries and then just as quickly start arguing. The truth, of course, is that when these arguments begin, the now well-worn positions on animal rights and welfare, as well as the "nature" of elephants, inevitably seem to trump the facts about which specific location and future might be best for a specific animal—and these are creatures, one should remember, that can live a long time and that require an immense amount of expertise and money for their care.

So, this was to be a project about elephants and keepers and relationships. It is also a project about how we can visualize an elephant and her or his life. There is actually a very old history of confusion about even the basic appearance of elephants; so much about them is different from other animals that artists in Western countries, at least, have struggled for a very long time to portray them. Obviously, by the time that photographs of elephants began to appear in the second half of the nineteenth century, most of the confusion about elephant anatomy, including the idea that the animals had no leg joints, had been cleared up. But there still seemed to be problems with how to get the large body of an elephant into a photograph while depicting its unusual qualities. As I began looking at more and more photographs of the animals, I began to feel as though there was a relatively small number of standard elephant photographs, and most were just variations on these standards. There were scale shots in which photographers positioned the animal near something relatively small, like a child or dog. There were side views and headshots. There were charging elephants, usually photographed in Africa, head-on, with ears projecting out to the sides. There were the photographs, especially from Asia, of working elephants in human contexts. There were all the photographs of elephants that in one way or another want us to believe that we are alone, calmly witnessing elephants in the wild, with no other human presence in the scene. And there were all the photographs of parts of the elephants, especially their tusks, skin, trunks, feet, tails, mouths, ears, and, more than anything else, their eyes.

Dick and I began to talk about photographing elephants differently. There were many photographs of elephants standing majestically in the wilds of Africa and Asia. There were plenty of shots, too, of elephants in zoological gardens, photographed to make it look as though they lived in a jungle, forest, or savannah. There seemed to be plenty of sentimental shots of elephants in the wild and in captivity, too. Our goal was to shoot something different, but we did not set out to reveal something more deeply authentic about the animals. We knew, though, that we were going to try to take photographs of elephants and humans together. Not because that is the best way to see elephants, but because the debates about elephants in human contexts engage important questions about our relationships and responsibilities to animals. The work we imagined would be straightforward and transparent: we would try to photograph the elephants in their actual circumstances and not try to hide the fact of their captivity, nor try to score

points for either side of the argument about whether elephants should be housed in zoological gardens. The conditions and lives of elephants in zoos vary a great deal, and every facility has strengths and weaknesses from animal husbandry and advocacy points of view. We hoped to find a zoological garden that was engaged enough with efforts to improve the lives of elephants that it would allow outsiders in to photograph their animals, staff, and facilities as we saw them, not simply as a marketing department might wish for them to appear.

Honestly, zoological gardens have every reason to be cautious when confronted with a historian and photographer showing up at the door wishing to take photographs of animals behind the scenes. We are all sensible enough to know that we would be anxious about the appearance of a "local news" team at the office, even if we hadn't done anything wrong. If someone comes to your workplace with a camera, a microphone, and an agenda, you know you can do little to protest—in the end, the news team will be the ones editing the film, and you will be the one who looks evasive. It says a great deal about the leadership and staff of the Oregon Zoo in Portland that our proposal to come and photograph their keepers and elephants in off-exhibit areas was met with encouragement, intellectual engagement, and proactive steps to move the project forward. The staff absolutely recognized that they could improve their facilities and were prepared to engage "outsiders" in the discussion. Since beginning this project, I have spoken to many people who care a great deal about elephants. Some have told me that the Oregon Zoo has a record of outstanding leadership in caring for elephants; others have told me that all zoos abuse their animals, including their elephants if they have them. I can say that from my decades of doing research on issues of animals and captivity, the places that concern me the most are those—whether zoo, sanctuary, or circus—that persistently resist any scrutiny from outside their organizations or a limited circle of accredited fellow travelers. The openness and transparency of the Oregon Zoo, including supporting this project, speaks volumes about the institution's commitment to its elephants.

Dick and I went to Portland to spend time with and photograph the elephants and their caregivers, but we quickly realized that the building housing the elephants would also be a major focus for this project: it was so much more than just a background, just an artificial set upon which animal and human dramas played out.[3] Looking back, this should not have been in any way surprising; the history of the zoological garden has always been about the display as much as the animals. Because of their size, strength, and the extraordinary amount of physical care they need, elephants have tended to be housed in specifically designed buildings. The elephant house at the zoo near where I live now is in many ways typical of the mid-twentieth century. It is a simple building with small rooms. The backs and sides are reinforced concrete, and steel bars line the front. The paint on the lower part of the walls has been worn off over time; above the height of the animals, the paint is beige and green and appears old. The floors are concrete, stained in rust colors and usually wet, as the keepers hose away and shovel relentless quantities of urine and feces. A huge tractor tire hangs on a wall at the back of one of the rooms, and an arc of black rubber marks the wall behind it, indicating that the tire has been the object of bored attention now and then. During the warm days of late spring, summer, and fall, the two female African elephants living there now spend most of their days walking around an outside, sand substrate yard surrounded by a dry moat. This yard is not that large, but the staff members keep it clean (bringing the animals inside regularly in order to clean it up) and try to make it interesting for the animals by placing piles of logs in the middle of it—a sort of giant's Jenga to amuse the elephants as they dismantle the pile looking for interesting things

to eat. There is a small pool out there, too, and a massive concrete representation of a baobab tree, put there presumably as a scratching post for the animals. During the long winter months, however, the elephants have typically only limited access to a shoveled area outside; most of their time is spent in a building that brings little pleasure to visitors standing in the cold, usually looking at the animals through steamed-up glass panels.

This elephant house was built in the 1950s, part of a large section of the zoo constructed at that time with classic gunite and moated exhibits for everything from bears to rhinos, lions, antelopes, hippos, and camels. If it looks rather sad today, it was state of the art at the time, built in a period during which designers felt that highly functional, understated buildings would encourage visitors to look at the animals in outside exhibits designed to appear as naturalistic as possible. Compared to its Pacific Northwest cousin, which was constructed to also house an adult male elephant as part of a breeding program, my city's elephant house is much, much smaller. In many ways, though, the two buildings are similar and are of about the same vintage. They were both originally built with a focus on relatively low-cost construction and simple ongoing maintenance, a commitment to showcasing the animals outside, and an awareness of the care and safety issues of housing exceptionally large, powerful, and dangerous animals that require close physical attention by keepers. Of course, it is possible to do much more with an elephant house. Arguably the most spectacular and famous elephant house built before these, for example, was the one built in Berlin some seventy-five years earlier, and comparing it to these mid-twentieth-century structures makes clear just how much ideas about exhibiting elephants can change in a relatively short period.

When the zoological gardens of Berlin opened in 1844, the institution was little more than a new home for the king's private menagerie, a home on property still belonging to the king but managed by a scientific society.[4] Partly the result of the king's waning interest in his collection, and partly the result of the efforts of a group of citizenry, the move led to a public zoological garden with modest scope and ambitions. However, in 1869—twenty-five years after the zoo's founding, three years after Prussian victory in the Austro-Prussian War, and just a couple of years before the victory over France that would lead to the declaration of the German Empire—the zoo at the heart of the Prussian capital of Berlin began a new building phase that would reflect the city's rising international status. In a context of accelerating economic and political power, and of an almost characteristic optimism about the roles of new public institutions, the zoological garden flourished. Of the original 1,000 shares of stock offered at the very beginning of the zoo's history at 100 thaler each in 1845, only 191 shares had ever been purchased. A new stock offering in 1869, however, first replaced those original shares and quickly sold the remaining 809 shares, yielding 80,900 thaler (almost a quarter million marks). The success with the stock sale was followed by two bond issues in 1870 and 1873, which together raised an additional 1.5 million marks, and with this capital the Berlin gardens began a building spree leading to some of the most spectacular buildings *ever* constructed in a zoological garden. By the end of the century, the Berlin Zoo had come to exemplify, arguably better than any other zoo in the period, the many goals of zoological gardens of the time: it was an institution committed to science, education, and recreation, but it was also fully expected to reflect the rapidly expanding economic, political, and military power of the German Empire.

Perhaps the most remarkable achievement of the early years of the renewed expansion program at the Berlin Zoo was the construction, in less than a year, of the new pachyderm building, called the Elephant

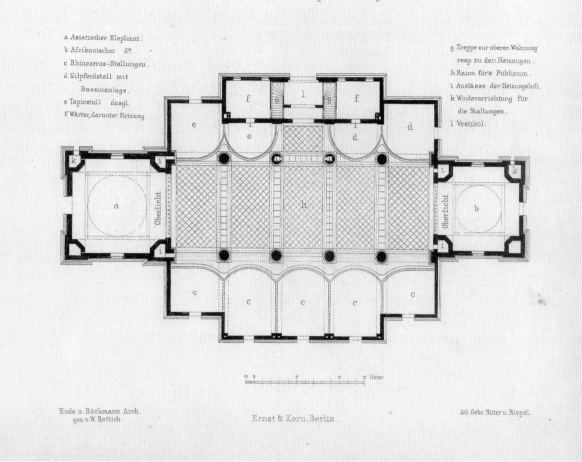

Plan of the Elephant House at the Zoological Gardens of Berlin, ca. 1876.
Author's collection.

House, which opened in 1873. At over 300,000 marks, the cost of the building exceeded the combined cost of *all* the construction that had previously taken place at the zoo.[5] As the floor plan (fig. 1) shows, the building was roughly a long rectangle. At each end was a square indoor enclosure for an elephant—at one end there would be an Asian elephant (*a* in the plan), and at the other an African specimen (*b*), both to be exemplary of their species. The center of the building (*h*) was the largest area and accommodated the public. Five indoor enclosures on one side of the building were to be used for various species of rhinoceros (*c*), and along the opposite side were two enclosures (*d*) for hippopotami and two (*e*) for tapirs. (One of the hippopotamus enclosures

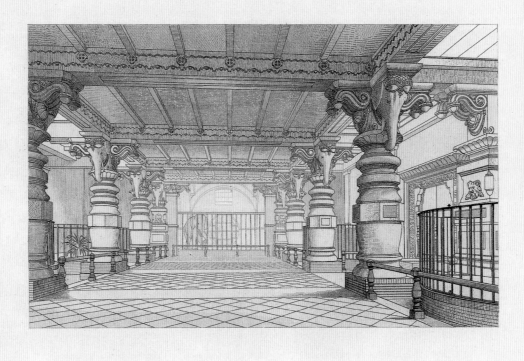

Zeitschr. f. Bauwesen 1876. Jahrg. XXVI Bl. 22.

Der zoologische Garten bei Berlin.

[FIG. 2]

Interior of the Elephant House at the Zoological Gardens of Berlin, ca. 1876.
Author's collection.

was designed as a pool.) The separate stalls for the animals were not particularly large, and the combined floor space of the interior was just over 12,000 square feet.

As can be seen in an illustration of the interior from the 1870s (fig. 2), the inside of the building was ornate, and the area for the public was rather dark; the exhibit spaces, on the other hand, were illuminated by skylights above the exhibits. As impressive as the inside of the building may have been, it was the outside of the Berlin Elephant House (fig. 3) that made it famous. At each end of the building, above the elephant exhibits, rose 60-foot towers, topped with shining gold suns and surrounded by four smaller towers of just over 40 feet each. The roof over the public space was flat, but those above the two side galleries arched gracefully in slightly pointed barrel vaults. The entire exterior surface was elaborately decorated with rug and elephant motifs designed with yellow, brown, and blue

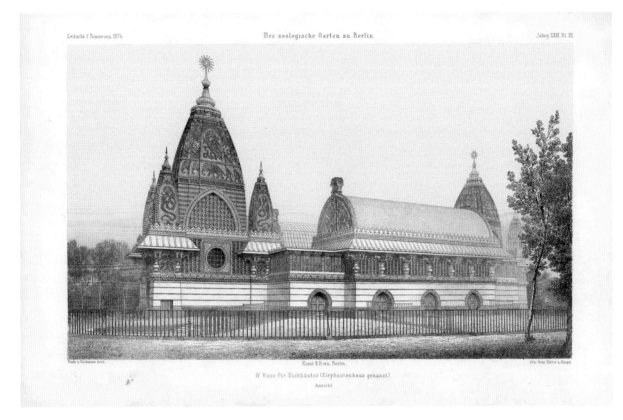

IV Haus für Dickhäuter (Elephantenhaus genannt).
Ansicht.

[FIG. 3]

Exterior of the Elephant House at the Zoological Gardens of Berlin, ca. 1876.
Author's collection.

tiles. Keyhole-shaped doors led from each of the indoor exhibits to separate outer yards, which, together, provided an additional 20,000 square feet of space for the animals. Echoing the preoccupation of the scientific community of the time, the building was designed to stress zoological taxonomy—each species of a group of closely related animals was to be exhibited side by side with the other species so that visitors could learn to discern the relations between animals. Similar lessons of taxonomy were presented throughout the zoo as visitors stood before areas devoted to wild cattle, deer, and kangaroos and visited the Bird House, the Large Carnivore House, the Bear Fortress, the Antelope House, the Crane and Stork Buildings, and so on. As much as these buildings were obviously designed around animal husbandry and a scientific argument, however, they were also intended as a kind of architectural collection. Like the ethnographic collections being assembled in the state museums, the zoo buildings in some sense represented aesthetic and cultural ideas—animals were to be presented in buildings that somehow echoed the human cultures of the native lands of key species within the buildings. Antelopes in Berlin, then, were exhibited in a sprawling building seemingly

plucked out of North Africa; the ostriches were shown in a fantastic ancient Egyptian temple; the elephants were exhibited in a supposed Hindu temple. If these new buildings were intended to portray exotic and often religious structures, however, in practice there was little that was sacred or even that exotic about them. With their animals and gawking public, the buildings quickly became merely decorative, vaguely suggesting cultures far away. They were undoubtedly impressive buildings, suited to the grandeur of the city, but in the end they still smelled of hay and animals, and it was still the animals that brought the audience to the zoo.

Constructed in the late 1950s with renovations and expansions in the '80s and '90s, the Asian Elephant Building at the Oregon Zoo today contrasts strikingly with the 1873 Elephant House in Berlin. Most obviously, while the Berlin building was fully intended to stand out as a human structure, the Oregon building is intended to be largely invisible and is designed almost entirely around the tasks of caring for elephants. Indeed, except for one room on the inside, Portland's elephant house is almost entirely inaccessible to the public. The elephants are to be observed outside, something achievable in part because of the relatively mild weather in Portland. From the visitor's perspective, the Asian Elephant Building consists of one indoor room and two outside yards—a front yard of 8,500 square feet and a back yard of over 25,000 square feet. Unlike the Berlin building, the outdoor spaces are not divided up into smaller enclosures for each animal of the building. These are open spaces with uneven surfaces and a sand substrate. Both yards have water elements; the water in the front serves as a pool and a barrier, while the water in the back is an 80,000-gallon pool allowing full submersion for the elephants. Although the building originally had simple 1950s lines, it is now hidden by artificial rockwork topped with plantings, designed

to look a bit like a cliff with inset cavelike entrances to the building's interior spaces. At about 15,000 square feet, the actual building in Portland is slightly larger in footprint than the old Berlin building, but this building shows none of the spectacular aspirations of the Berlin house. This is not a facility designed to showcase individual animals and situate the viewing public centrally; it meets the husbandry needs of a group of elephants, and while the exhibit exists because of public interest, the public, itself, has been moved to the periphery. Rather than walk by stalls housing individuals of different species, now the public watches groups of elephants interacting with each other in larger open areas and the building itself has, as much as possible, been made to look like a natural background.

The building is currently managed by a team of five full-time staff and a larger number of volunteers and interns. It is home to eight elephants, including Packy, who was born in Portland in 1962—the first elephant born in North America in over forty years—and Lily, who was born at the zoo exactly fifty years later, in 2012. In addition to these two, there are three other males: Rama, a son of Packy's, born at the zoo in 1983; Tusko, a large wild-caught male born around 1971 who came to Portland from California in 2005; and Samudra (Sam), a son of Tusko and brother of Lily, born at the zoo in 2008. There are three other females, as well: Sung-Surin (Shine), a daughter of Packy's, born at the zoo in 1982; Rose-Tu, who was born at the zoo in 1994 and is the mother of Sam and Lily; and Chendra, an orphaned elephant from Borneo, born in 1993. Photographs of all of these elephants and some of their recent caregivers appear in this book. There is a great deal that could be said about the personal and professional paths of the staff, their hopes and aspirations, and why they think the work they do is important; there is also a great deal that could be said about the lives of each of the elephants in this collection, as well as all the many other

elephants who have lived at this zoo. We all have an impulse to know these biographies. It is natural, when at the zoo, to wonder how old an animal is, how long it has lived at the zoo, and how a person gets to work there. However, the focus of this book is an effort to convey a sense of the circumstances in which elephants and those who care for them interact at a zoo, and this is not the place for accounts of all the individuals. Still, it would not be possible to write this essay without noting, at least briefly, the story of the most famous animal to have ever lived at the Oregon Zoo: Packy.

When I was growing up in the 1960s and '70s, Packy was one of the first "celebrity animals" I knew about. Covered in a full-length *Life* magazine article after his birth in 1962 and then in decades of articles and TV programs, Packy's story was part of my childhood, and it mixed with those of many other animals, including Snowflake, the famous gorilla in the Barcelona Zoo; Shasta, the liger at the zoo near where I grew up; David Graybeard, the chimpanzee that reached out to Jane Goodall; and Elsa, the lion who was "born free." It was thus with some anticipation that I found myself finally standing with Dick in the public area of the Asian Elephant Building, waiting for the then fifty-year-old Packy to walk in through an open, reinforced concrete door at the back of the building's indoor exhibit, a door operated by a hydraulic system that seems very old but is nowhere near as old as this elephant. Packy has lived in this building longer than almost any other animal anywhere else at the zoo. Over the decades, hundreds of staff members have helped care for him, and most of these have since retired. Dr. Matthew Maberry, the veterinarian who was in his forties when Packy was born, for example, died in 2012 at the age of 94.[6] Millions of visitors have seen Packy, and people are bringing their grandchildren to see an elephant today whom they themselves saw when they were children. There are those who think of a very long life like this and wonder whether it is a somehow sad way to live, or whether Packy would have been better off not to have lived this long. When I look at photographs of Packy as a very young elephant in a group of others, including his mother and father (fig. 4); when I think of all the many different people who have cared for him and whom he has known, how they have spoken to him and touched him as they have washed him with brooms, soap, and water, how they have cleaned his feet, given him special treats, and attended to him when he was not well; when I think of the very many other elephants he has lived with over the years, and of the young elephants who have toddled around him; when I think of the challenges he has faced in learning new management techniques as the practices of caring for zoo elephants have changed over the decades; and when I think honestly about the very few elephants in the world (whether in captivity or in the wild) who have lived anywhere near as long and healthy a life as he has, I tend to think that he was far from unlucky to be born at this zoo.

Dick and I were standing with a group of children and their parents as Packy began pulling down and devouring hay from a high slinglike contraption made of woven fire hoses. It is difficult to get a sense of just how big he is. First, it is important to realize that there are relatively few adult male elephants in North America. Almost all the elephants that most people have seen in zoos are females. Because of their size (male elephants are typically much larger than females), but even more because of their nature (physiologically and otherwise), most older male elephants—and we have to say "most," because generalizing about animals both makes sense and clearly doesn't—have not been that well suited to zoos and circuses because they tend to be less interested in staying within a close group (which might include people). Suffice it to say that what struck Dick and me so strongly at this moment was that this animal seemed impossibly large for the room. He seemed, in fact, like

one of those giant sculptural figures in a temple, a figure so big that one can't imagine how such an object, such an entity, could actually get inside the building.

Thinking about temples and gods actually came to us surprisingly easily when we were visiting in Oregon. In the back of my mind, I had already been thinking about how many earlier elephant buildings (like Berlin's in the nineteenth century) were built to resemble a temple, and then Dick said something that made me consider the issue more carefully. As we began to get to know the people who were caring for the animals, and as we began, too, to recognize the day-in and day-out patterns and habits of activity around the building—the animals moving from the yards, to indoors, to the yards; the regular teams of staff and volunteers heading out to the vacated areas to shovel waste, rake, build structures, spread browse, hide food, and clean up before another group of elephants entered; the daily routines of bringing elephants individually into the "sun room" or a stall to wash them and care for any injuries or illnesses, do daily foot maintenance, and just give the animals some pleasant time with the people who care for them, time with special treats, physical contact (albeit through protective bars), and friendship—Dick described the keepers' work to me as "devotional." The people cared for the animals not because they had been told to do so as part of a job they didn't like, not because it led to a specific outcome, but because simply caring for the animals was what mattered, was what gave meaning to the work they were doing, was what made this job of cleaning up shit, hauling hay, and answering the same questions of the public every day the job that they wanted more than any other.

Of course, few if any giants—or gods—are cuddly. They can be violent, wise, generous, and unpredictable, and in some cases the best that humans can do is enclose them, even if only metaphorically, in a temple. There, the god can be cared for and venerated; sacrifices

can be made, and specific nourishment brought. In controlling such giants and dangerous creatures, we make, it seems, a peculiar bargain, a bargain perhaps at least partly behind the origins of the veneration of the elephant-headed god Ganesh:[7] we will care for you, we will honor you, and we will try to stay out of your way, but we beseech you not to hurt us. But elephants remain powerful creatures, even when we keep them in captivity, even when we form genuine friendships with them, even when we trust them and they trust us. The truth is that people have been killed caring for elephants, and this has happened in forest lumber camps, city streets, zoos, circuses, and sanctuaries. The staff at the Oregon Asian Elephant Building always carry a "guide" (sometimes known as a "bullhook" or "ankus") when working around the animals. For many critics of keeping elephants in captivity, the guide, a literally ancient tool for managing elephants, is very controversial. People see the hooked steel tip of the tool and think it must be used to cause pain. To be sure, the guide can and undoubtedly has been used to cause pain by elephant keepers for millennia. With that said, we have all seen people training dogs or horses, and the best trainers seem to be successful not because they are creating pain for the animals but because of the clarity of the trainers' expressions, their general calmness in working with the animals, their sparing use of "negative reinforcement," and the trust that the animals seem to have in them. The elephant keepers I have come to know and respect over the course of recent decades—people working with elephants in all kinds of settings—are not monsters. They care deeply for the animals and are exceptionally effective at working with them precisely because they don't use the guide as a weapon.

That many people involved with captive elephant management believe that elephants should be trained, wherever possible, by using only positive operant conditioning and by keeping safe barriers between staff and

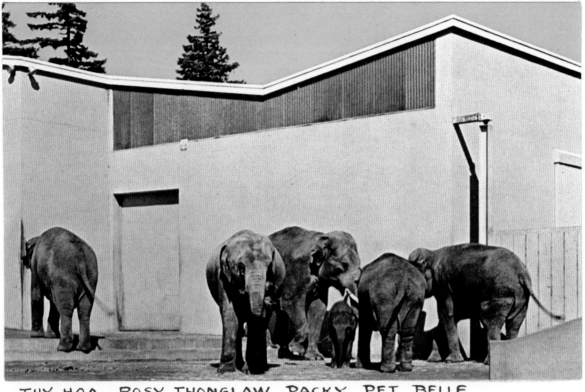

TUY HOA, ROSY, THONGLAW, PACKY, PET, BELLE

CWi 2000

[FIG. 4]

The Portland Elephants, summer 1963. By permission of Circus World Museum, Baraboo, Wisconsin, CWi 2000. CWM Ph 7, Chang Reynolds Papers, box 16, folder 15.

elephants at all times (what is usually called "protected contact") tells me, in the end, less about the best approach for handling specific animals in specific facilities and more about the evolving discussion about the best kinds of relationships to have with "nature" and animals. As part of moving to a new facility, which I will discuss below, staff members are, in fact, transitioning the animals and their own procedures to a "protected contact" model. In just the couple of years that Dick and I have been visiting the zoo, for example, we have noticed that it is now an exceptional circumstance that would lead the keepers into one of the yards with the elephants, but that practice occurred almost daily during our first visit. Indeed, at that time, when Samudra was still quite young and Rose-Tu was pregnant with Lily, Rose-Tu had daily training with the keepers to maintain her physical condition during her pregnancy. A photograph of these "workouts" is included in this collection. In any case, for now, the guide remains standard (though increasingly less used) equipment for this staff, because they believe

that ensuring the highest-quality care for the animals and the safety of the staff requires that the keepers still be able to enter exhibits with the animals when absolutely necessary.

The public exhibition areas at zoos are generally designed to be upbeat, fascinating, educational, and ultimately fun places. Although there are often educational signs about the difficulties that the animals face *in the wild*, the messages in the exhibition areas usually direct our attention to the work that is being done—ideally by the zoo itself—to protect the animals from the dangers of climate change, human encroachment, hunting, and greed. But the off-exhibit areas are always very different. If the public areas deploy the theatrical scenery with which we are all familiar at zoos, scenery meant to make us feel that we are looking into a somehow "natural" landscape and to make us more comfortable with the captivity of the animals, the off-exhibit areas tend to be highly functional places. They are designed so that those caring for the animals can access them as necessary, clean the "cages," "enclosures," or "habitats" efficiently, and provide food, water, medications, and the like safely. Most of the Asian Elephant Building in Portland is off-exhibit and consists of a series of rooms in which the animals can be accommodated for longer periods, or through which they move on their way to the outside yards. Currently, for example, although the three adult male elephants can smell and hear each other, can touch trunks and otherwise communicate, they are not put in a single yard or internal room together. This means that one can be in the front yard, one can be in the back yard, and one has to be in one of the inside rooms. The keepers frequently rotate them around so that they do not spend too much time in any one spot (the longest periods being typically overnight), and the elephants themselves seem to know all the moves before they even happen. As a door opens, they wait for a release command from one of the keepers (this is a bit like when your dogs are waiting while you prepare their dinner), but the moment the command comes they move quickly to their next spot, where they know they will find special treats. The females and the younger elephants (including the young bull Samudra) can be together and with the adult males, so over the course of a day, the elephants will be in a variety of different size groups and combinations. Lily, at this point, is always with her mother, as was Samudra when he was younger.

The inside of the elephant house—at least where the elephants are—is a highly controlled space. The public exhibition room is larger and lighter than some of the others. There is a central room called the sunroom, because of the brightness from the skylights, where most of the direct care of the animals occurs. The floor there is rubberized and easier to clean and disinfect, and the keepers have access through bars so that they can wash, clean, and spend time there with the animals. Then there are a number of smaller rooms, with lower light, that seem simultaneously gloomy and somehow comforting in their closeness—these rooms are more like the stalls you might find in a horse barn, but here they are made of concrete. There is also an iron "squeeze chute" for controlling the elephants when the keepers are working on the animals' feet or completing some medical procedure. I think most of us would shy away from this rather ominous-looking structure, but the elephants walk in confidently, apparently knowing that during the time they are in the chute they will also be eating some of their favorite foods. (It may also be, as Temple Grandin suggests, that the closeness of the chute and stalls can be fundamentally calming for the animals.[8]) Overall, the impression in these rooms is one of order and efficiency. Even the highly clipped, strikingly clear, and obviously carefully defined communication protocols of the keepers—protocols stipulating that each person declare his or her actions to everyone and that all relevant others provide a clear affirmation

of their understanding of the situation ("All clear to open the door?" "Yes, ma'am, all clear!")—emphasize that this space, from the keepers' perspective, should be regarded as highly professional. There is simply nothing haphazard about the human activities in these rooms, even though the animals seem very relaxed. Blue wheelbarrows and white shovels are thoroughly cleaned after each use and lined up for quick access; fresh sawdust is put over the floors after each cleaning; mechanicals are regularly checked and hoses properly stowed after each use. Nothing is left lying around casually.

Some people seeing this space for the first time—and seeing some of the images in this book, as well—might think that this off-exhibit area looks very stark and perhaps even a bit frightening. To be clear, this building has been designed to contain and control immensely powerful creatures; it does not pretend to be some sort of "natural landscape." With its reinforced concrete walls and floors and heavy steel bars, the building can be intimidating, but if you spend any time there, it becomes completely evident that this is a very caring space. Dick and I often noticed how much the animals and the people working with them enjoyed the time they spent with each other. A warm-water hose seemed to be the perfect entertainment for the elephants—especially the young ones, who loved to splash around the sunroom. And, for all its efficiency, for all its focus on the physical health of the animals, the building also had a gentler, more relaxed, never stressed-out quality. The building smelled of hay and sawdust and the light was soft. There were the ever-present house sparrows hopping and chipping about, stealing bits of food and nesting materials; the constant low din of an old boom box playing classic rock; the small keepers' offices, where foods were apparently almost constantly being prepared for the elephants and where sweet pastries brought in by the volunteers seemed ubiquitous. There is a long tradition of referring to places where elephants are kept as "barns," and that is

the unofficial term used for these buildings in most zoos. While zoo visitors may come to see the "elephant house," the animals live and the keepers work in a "barn"—a term that points to a particular kind of calm domestic space shared by people and animals.

All zookeepers these days recognize that the interface with the public is a critical part of their jobs; a job at a zoo is no longer an escape for people who prefer to be around animals. But if engaging with the public is necessary and important, taking care of the animals in the off-exhibit areas is probably what makes the job most fulfilling for most of the keepers. On the faces of people working closely with elephants in zoos, circuses, and sanctuaries, I have seen, again and again, an expression of intense focus on caring for the animals. One day while we were in Portland, we were watching Packy being washed by the staff while we talked to Mike Keele, who had cared for the elephants decades before (and who has written the foreword to this volume). The keepers asked Mike if he would like to take a turn at the broom and the soap. As he took hold of the broom, it was clear that Mike was transported back to the work he used to do every day. His face was red and glowing afterward as he explained that this was a very special day, indeed. Physically caring for such remarkable animals—cleaning them, feeding them, playing with them, learning about them, and knowing that they are learning about you—is what makes this a dream job for a group of remarkable people. I don't really think it is that difficult for those who do not work with elephants every day to understand most aspects of this work. It is a combination of heavy physical labor, intellectual discipline, and intuitive empathy all directed toward keeping very large and intelligent animals clean, physically healthy and fit, and mentally engaged in circumstances which, by their very nature, work against keeping very large and intelligent animals clean, physically healthy and fit, and mentally engaged. Many of the tasks turn

around the constant efforts to keep the animals and their quarters clean. This means, for example, daily bathing of the elephants—and this task is simply hard work. It means constantly shoveling their droppings. It also means daily maintenance of the animals' feet, because chronic foot infections are a major—and, fortunately, diminishing—problem for captive elephants. It means coming up with a range of enrichment activities that challenge the animals intellectually and physically. It means being aware of the physical and emotional health of each of the animals so that any special needs can be met. And this happens every day of the year, year after year. It also means finding time for the animals to just be together in various combinations throughout the day. And almost all of this happens in places and ways that the public doesn't see. This is why we wanted to take these photographs; we wanted people to see and begin to understand the caring that can take place in such circumstances.

Over the course of the project, Dick and I, along with our collaborators at the zoo, realized that we were also documenting a moment in the lives of a group of remarkable animals and also a moment in the history of elephant management in zoos. At the very time this book will appear in print, the building where these photographs have been taken—a building that has served as a home for elephants for over sixty years—will have been razed and replaced by a newer, much larger, and simply much better Elephant Lands exhibit. The Asian Elephant Building was among the best of its time, but that time has clearly passed. Because the leadership of the Oregon Zoo advocated for better facilities for the animals in their care, because of the clear interest of the public in supporting a zoo that aspires to be better and not simply carry on, and quite possibly because of the significant place that elephants—and in particular Packy—have occupied in the awareness of Oregonians, the zoo is in the process of radically expanding its elephant facilities. These new buildings and landscapes for the animals will make husbandry ideas that seemed like pure fantasy a few years ago into reality. In the new yards, for example, randomized automated feeders distributed around the long distances of the yards (the designs are longer rather than broad, to encourage more walking) will provide smaller amounts of food 24 hours a day to eliminate the binge eating of current facilities and provide a digestively and physically more healthy eating-while-walking pattern for the animals. In Elephant Lands, moreover, the animals will be able to choose for themselves whether to be in the main house or in the outside yards at night and will be able to move in and out as they wish. Because of its extraordinary size, as time goes on, different groups of elephants will be able to build more stable relationships with one another by making choices for themselves about where and with whom to be. Over time, it may even be possible that a bachelor group will develop—something that has simply never been possible in a zoo before. All of these changes mean that the elephants will have less and less direct daily engagement with the staff of the zoo. There are concerns in all this, but the vision of Elephant Lands is that the potential risks to the animals (for example, that the staff will face increased difficulty in providing immediate medical care) and the increasingly fewer opportunities for the staff and the public to be close to the animals are outweighed by the benefits to the elephants. In short, the elephants will simply have more control over their lives. Dick and I have been repeatedly struck at how much the management protocols of the elephant program at the Oregon Zoo have changed in just the two years we have been engaged in this project; it is difficult and exciting to imagine how different the place will be ten years from now.

In 1991, the *New Yorker* published a translation of Haruki Murakami's short story "The Elephant Vanishes." The

story is told in the first person by a man who works in the public relations department of a manufacturer of electrical appliances. The man's life is one of pragmatic repetition, but he is also fascinated with an aging elephant and its keeper at a zoo, an elephant and keeper who one day both *vanish*. Sometime later, at a reception launching a new coordinated line of kitchen equipment, the man meets a woman and, over drinks, he mentions the elephant. She asks him, "Weren't you shocked when the elephant disappeared? It's not the kind of thing that somebody could have predicted." His response causes a great deal of confusion. He says, "No, probably not." Just why the man is not shocked seems to be never satisfactorily answered from the woman's perspective. I think that the answer to so much of what is confusing for people about this story turns on the peculiar—somehow incomprehensible and maybe even magical—relationship of the elephant in this story with its keeper when the animal is off exhibit and the two of them are alone and believe they are not being observed. In the end, I think the man is not surprised because he has been watching the keeper and the elephant behind the scenes, through an air vent at the back of the building. Coming to understand them as more than a keeper and an elephant made it possible for this man, whose life turned on the quotidian and the obvious, to know different possibilities in relationships between animals and people. We hope that this book will help others imagine these sorts of possibilities, as well.

[notes]

1. For more on Hagenbeck, see Nigel Rothfels, *Savages and Beasts: The Birth of the Modern Zoo* (Baltimore: Johns Hopkins University Press, 2002).

2. I use the word "ambitious" here because I think it does a better job than the more common term "good" in demarcating those contemporary zoos striving to be at the forefront of the industry. While there have always been a great variety of zoos and animal parks of one kind or another, from pet shops to sanctuaries, to game parks, to small private and public collections, to huge public and private institutions, there has also been a very long practice of talking about "good zoos." We have all heard statements that begin something like, "Well, at least at good zoos. . . ." Today, "good zoos" seems to be an accepted shorthand for large, generally not-for-profit, municipally funded, accredited institutions that foreground missions of conservation, education, and science (and usually in that order) over recreation. People inevitably quibble about what each of these terms might actually mean, though, and clearly "good" is not a very helpful term here, because it is obviously the case that some so-called good zoos regularly engage in ethically dubious activities, and some smaller institutions, not accreditable by the main institutional self-accrediting bodies, maintain high ethical standards.

3. Many years ago, I asked Dick's father, Herbert Blau—the prolific theater director and writer on performance theory—about connections between zoo exhibits and theatrical exhibits. He quipped, characteristically, that of course zoos try to make dramatic sets. It is just that they do it badly!

4. For more about the history and buildings of the Berlin Zoo, see Ursula Klös, Harro Strehlow, Werner Synakiewicz, and Heinz-Georg Klös, *Der Berliner Zoo im Spiegel Seiner Bauten, 1841–1989: Eine Baugeschichtliche und Denkmalpflegerische Dokumentation über den Zoologischen Garten Berlin* (Berlin: Heenemann, 1990).

5. Ibid., 70.

6. For more on Maberry, see Matthew Maberry, Patricia Maberry, and Michelle Trappen, *Packy and Me: The Incredible Tale of Doc Maberry and the Baby Elephant Who Made History* (Portland, Ore.: Amica, 2011).

7. On the rise of the cult of Ganesh and its relation to the history of human-elephant conflict, see the argument by Raman Sukumar in *The Living Elephants: Evolutionary Ecology, Behavior, and Conservation* (New York: Oxford University Press, 2003), esp. 64–70.

8. See, for example, Temple Grandin and Catherine Johnson, *Animals in Translation* (New York: Scribner, 2005).

[photographs] DICK BLAU

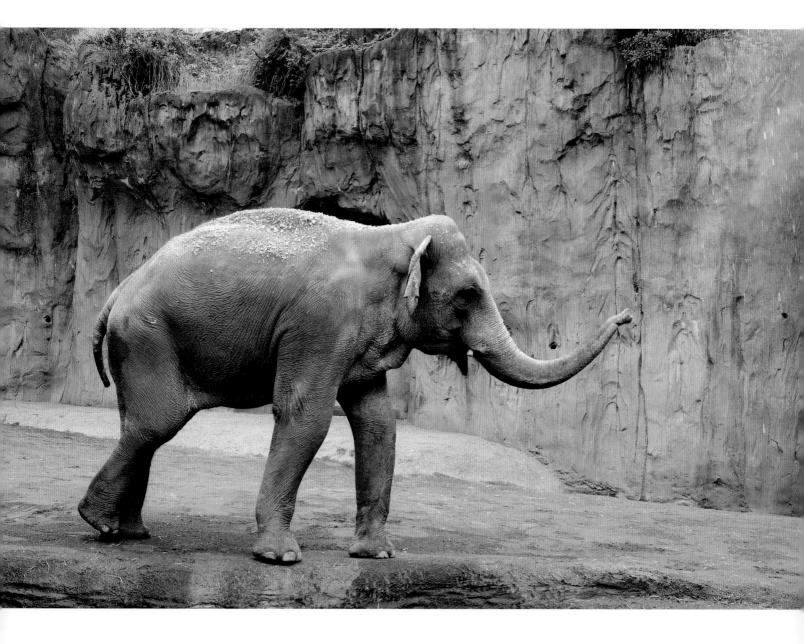

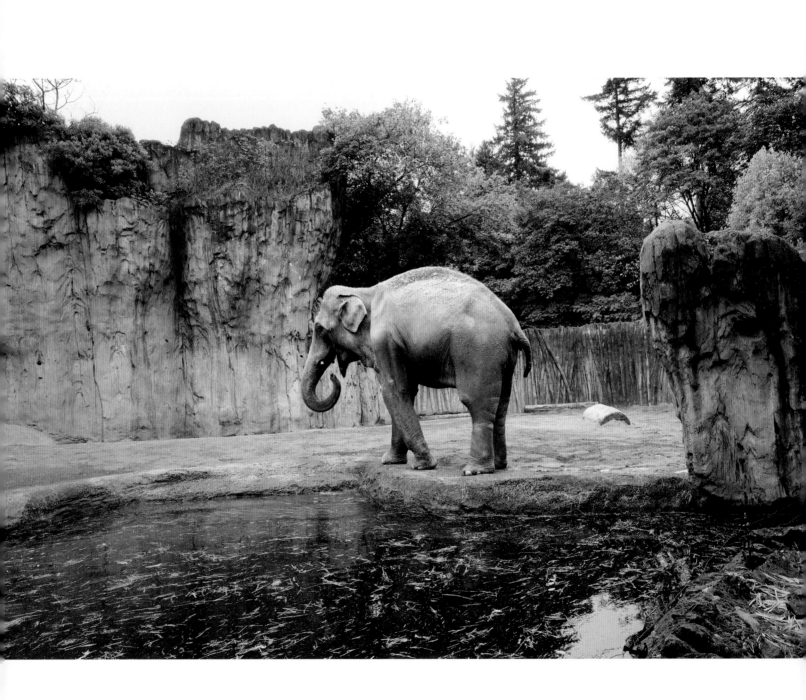

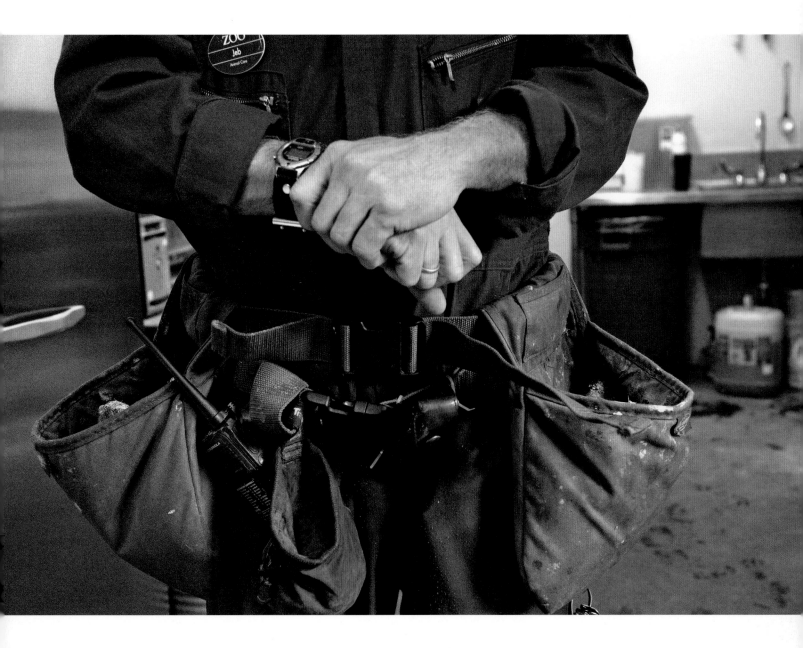

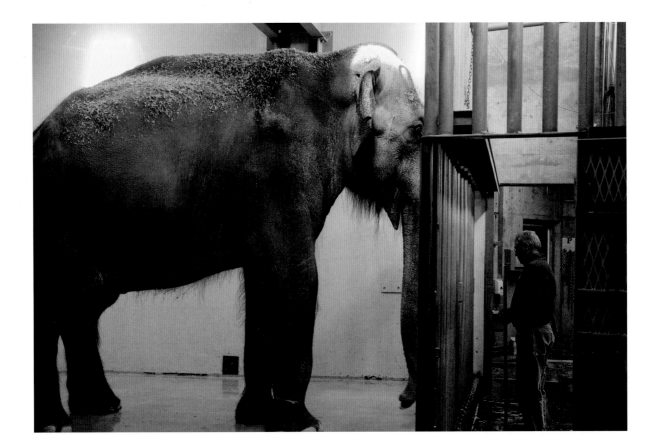

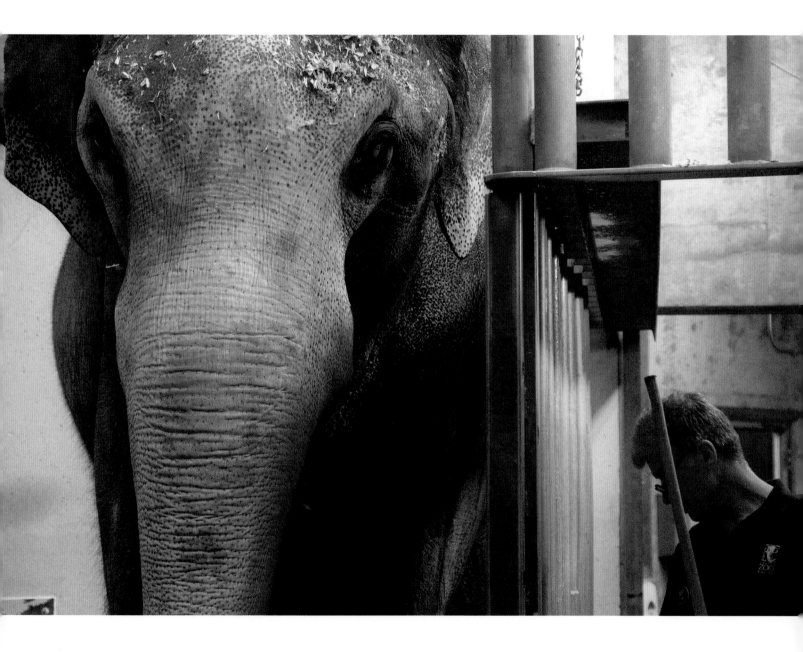

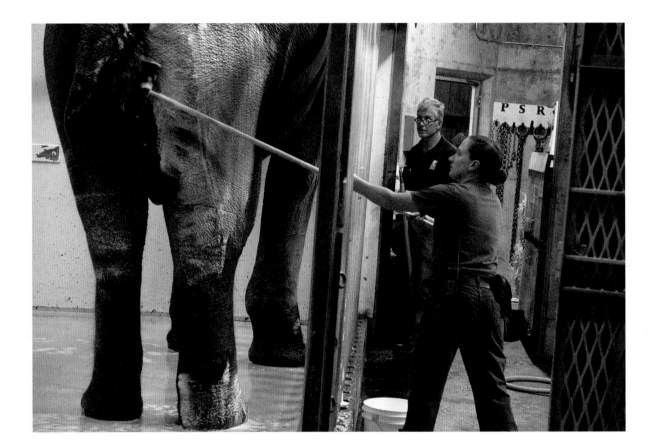

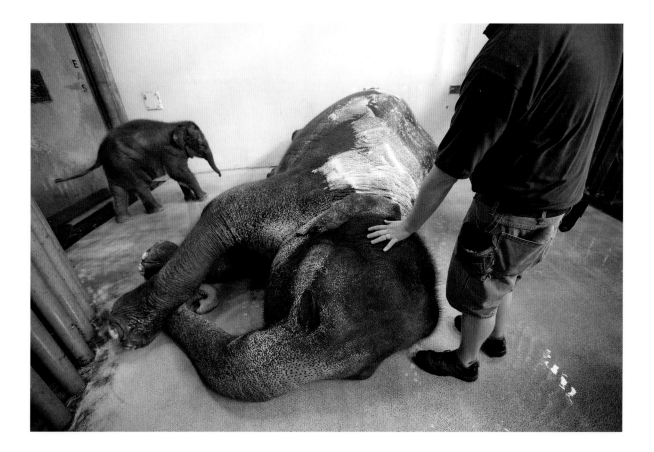

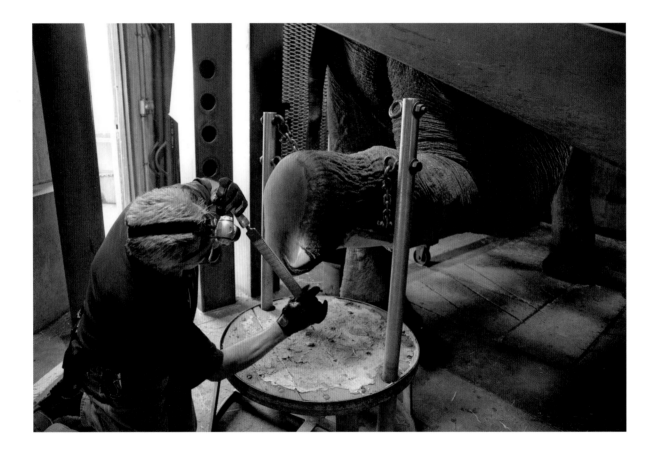

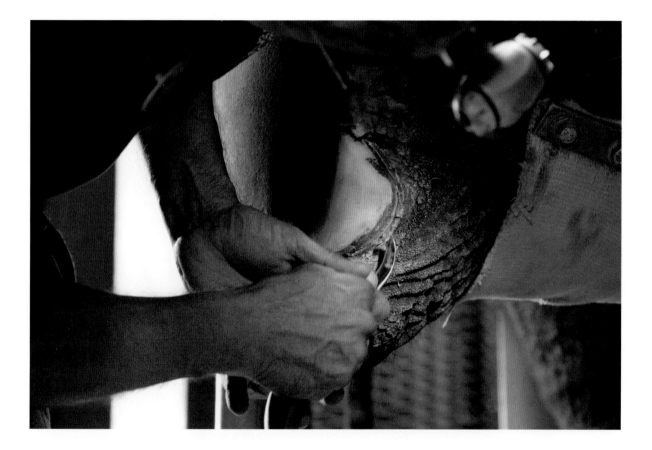

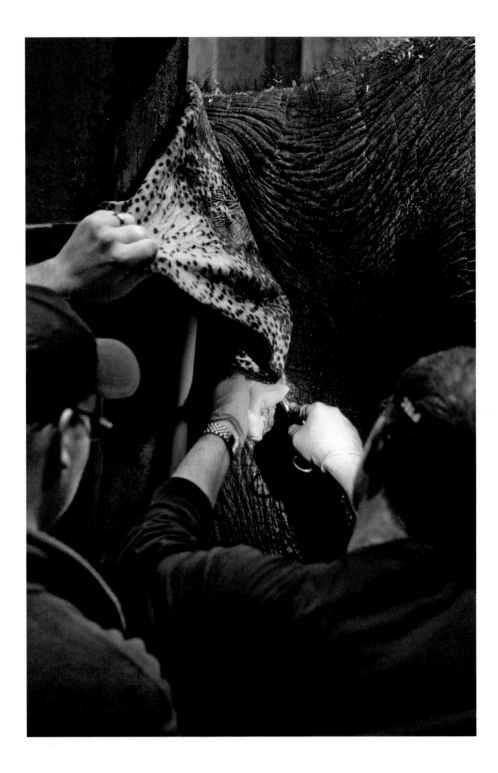

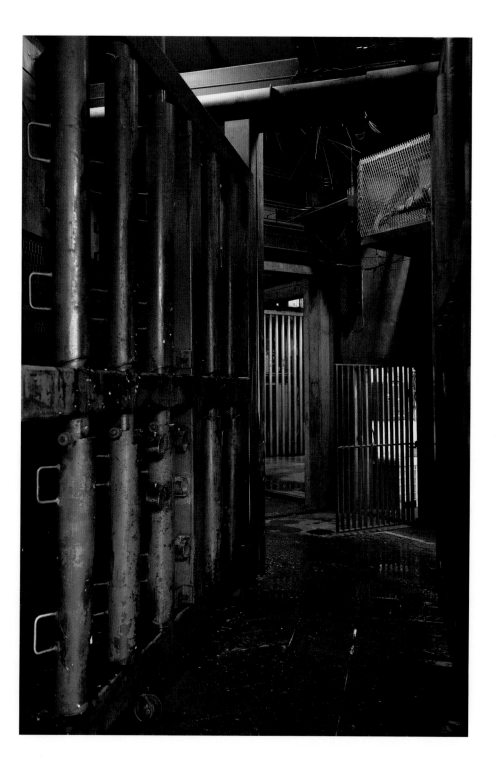

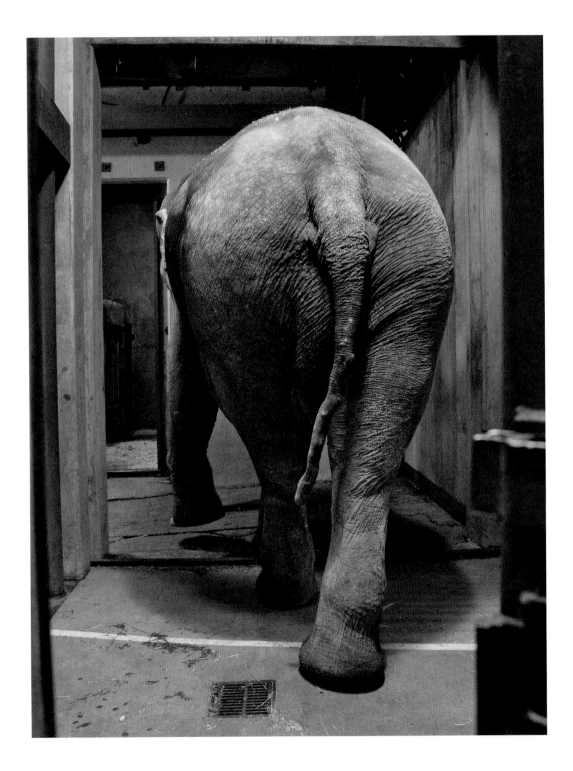

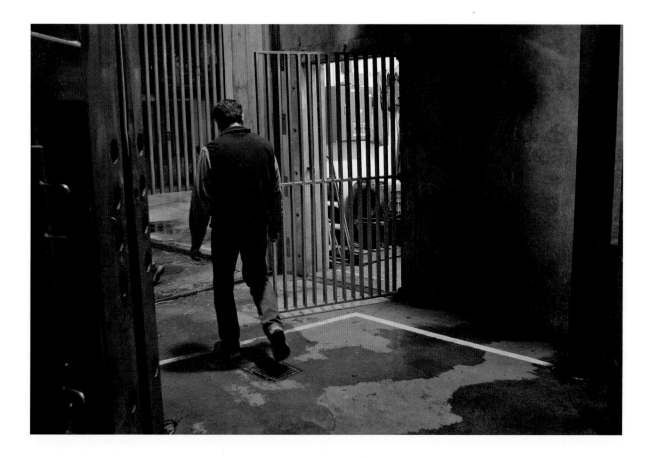

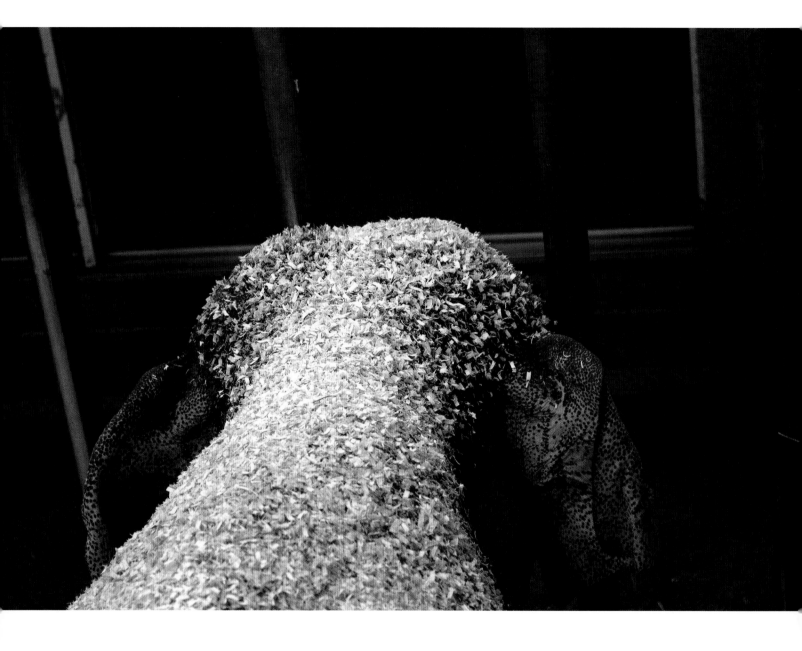

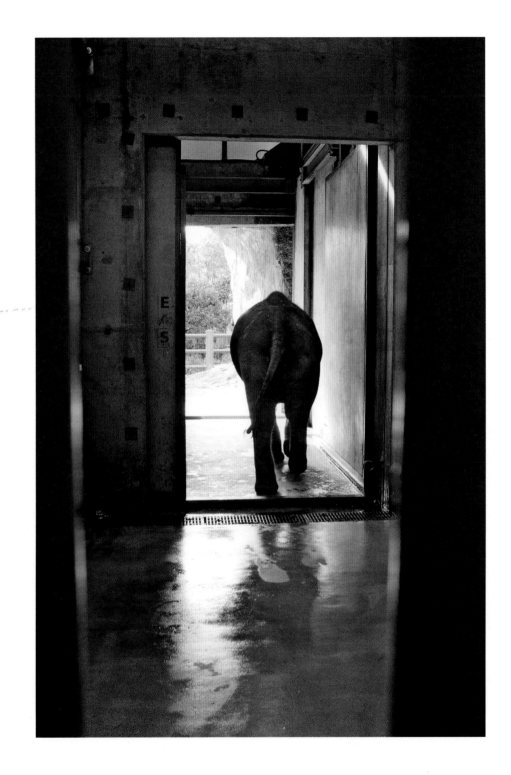

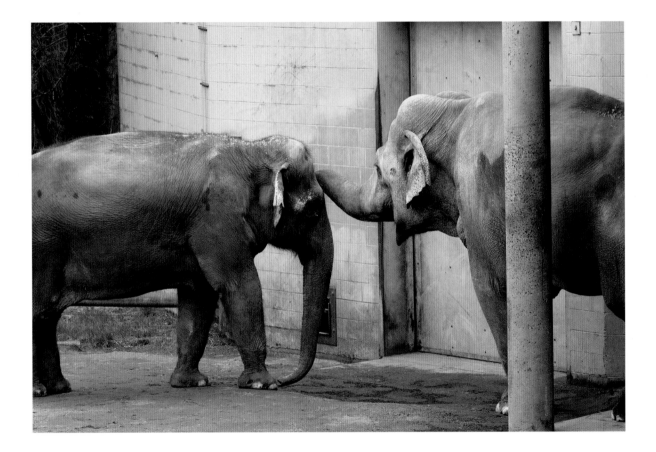

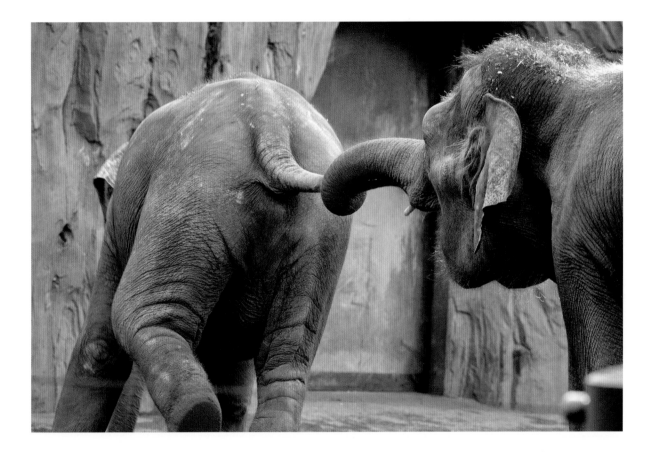

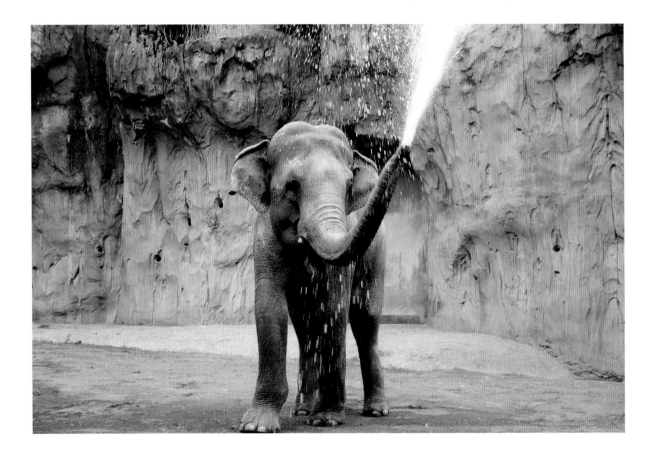

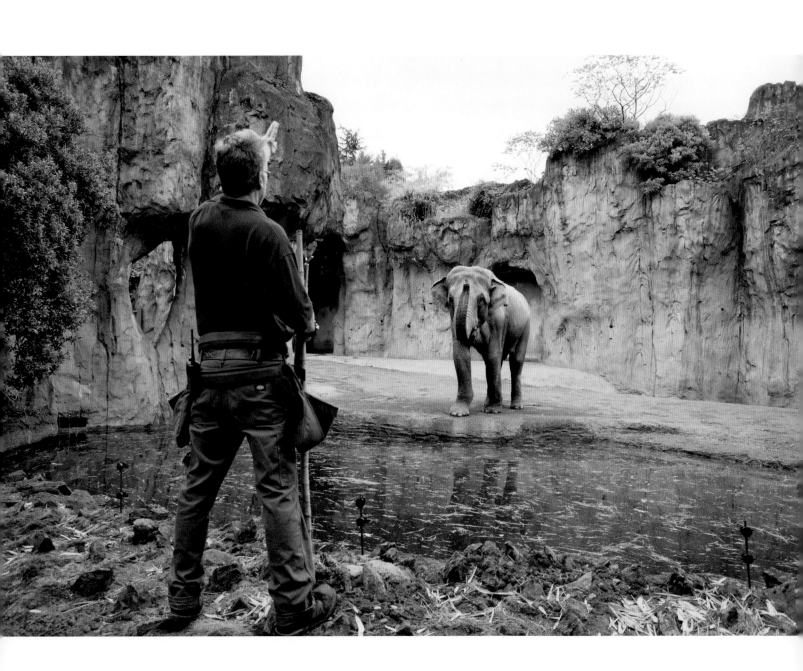

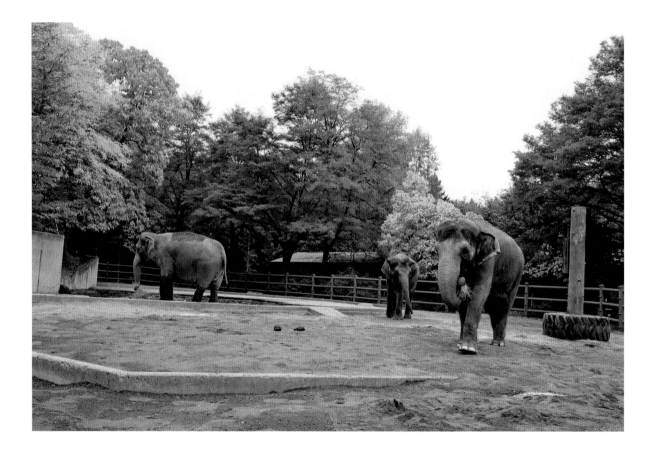

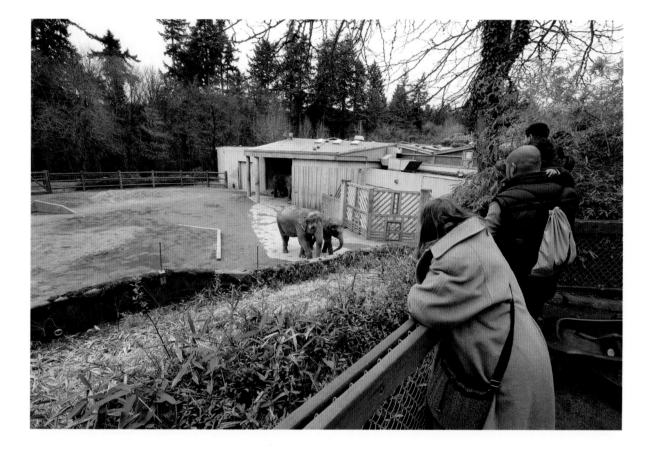

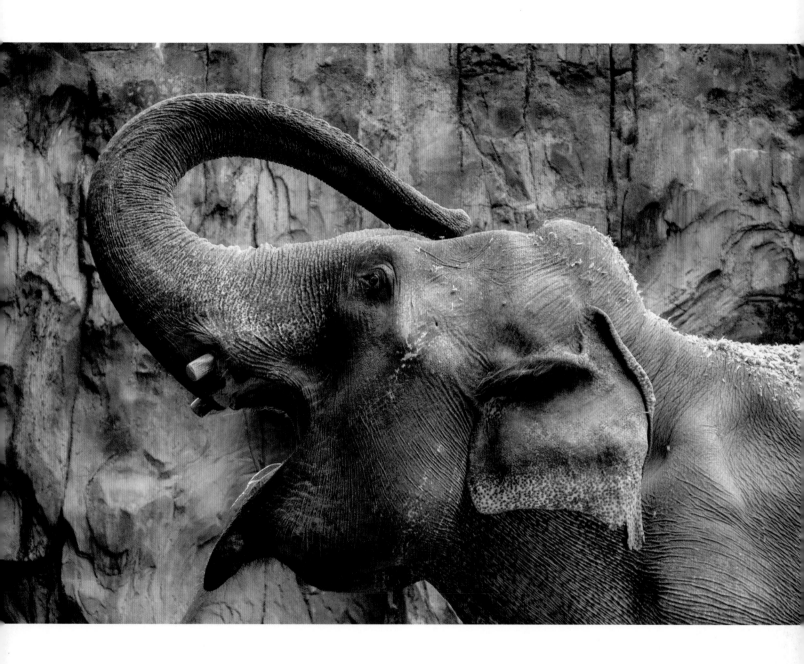

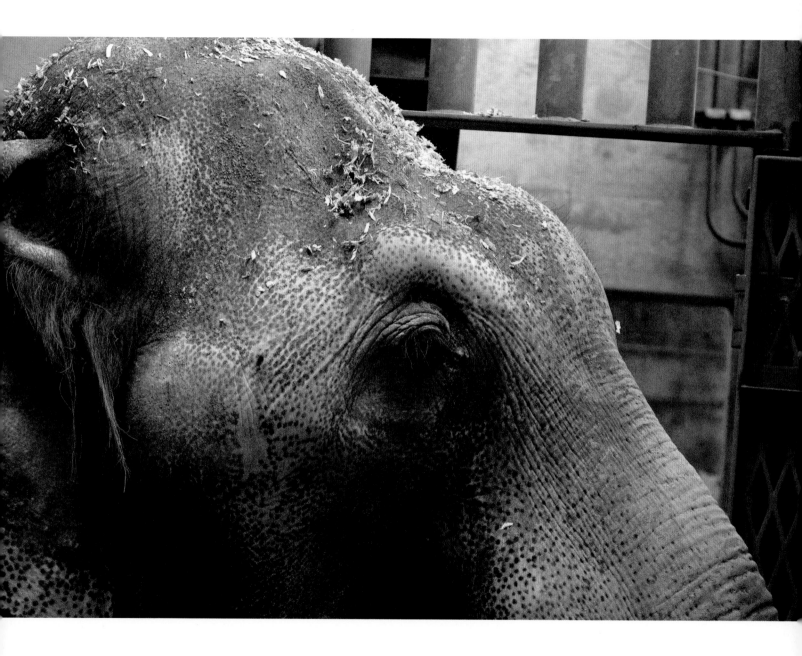

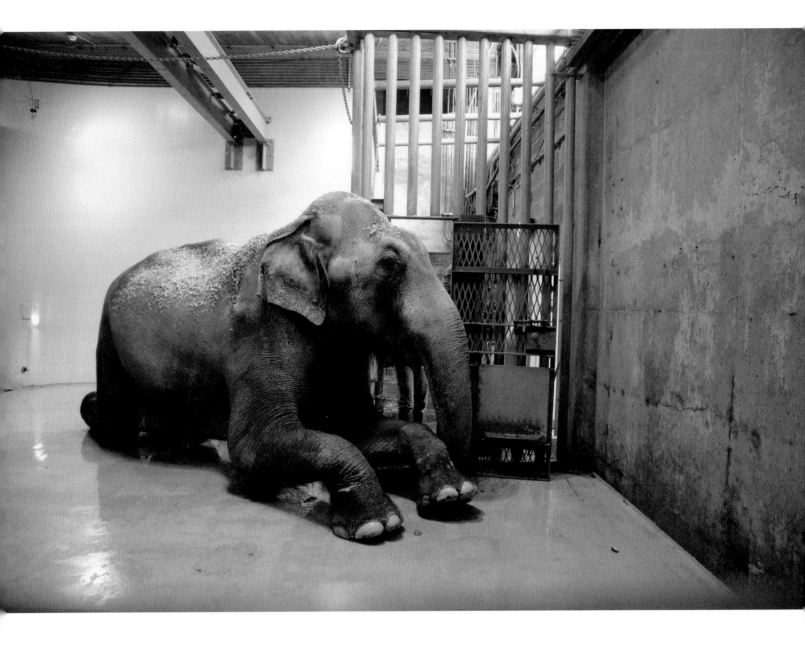

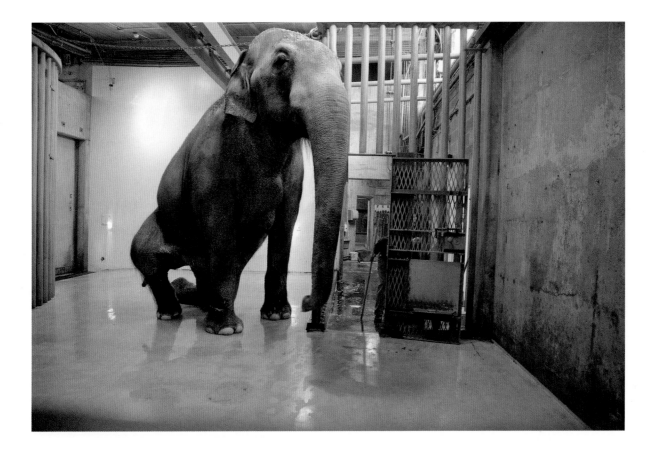

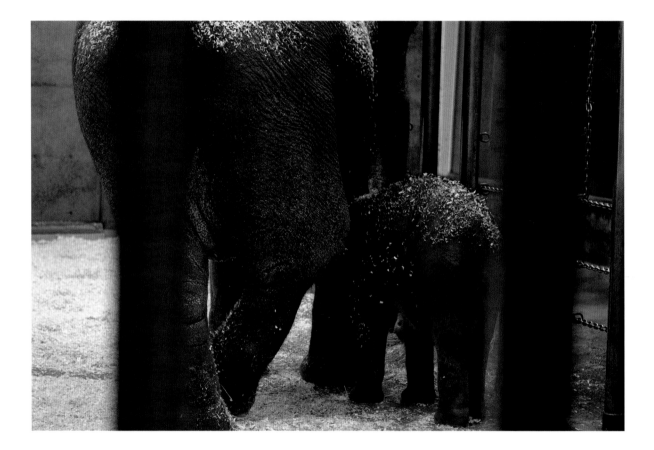

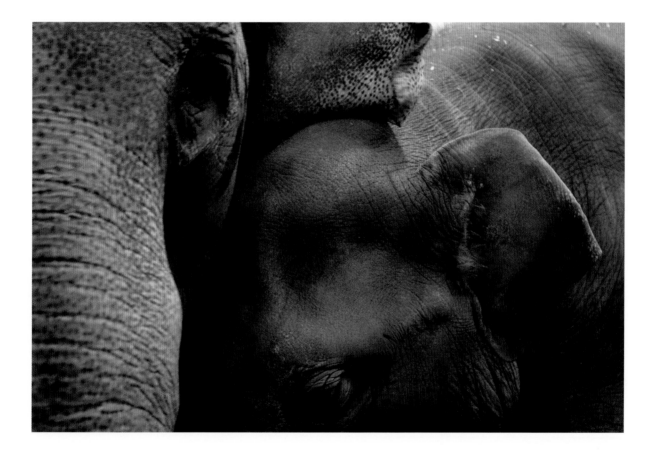

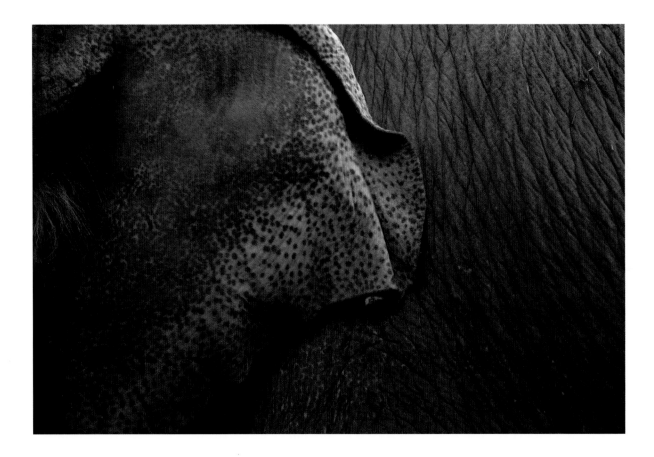

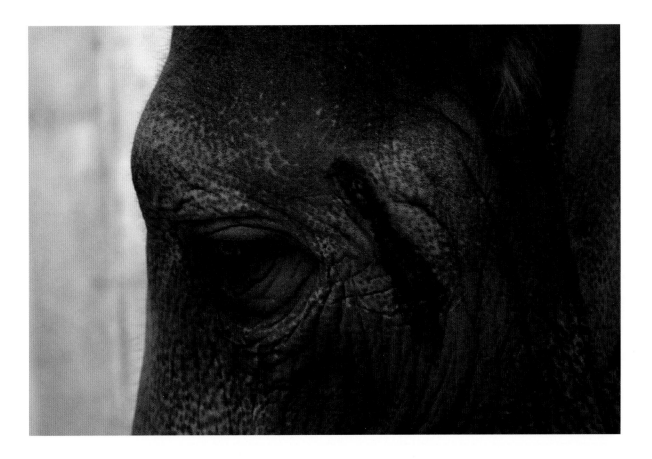

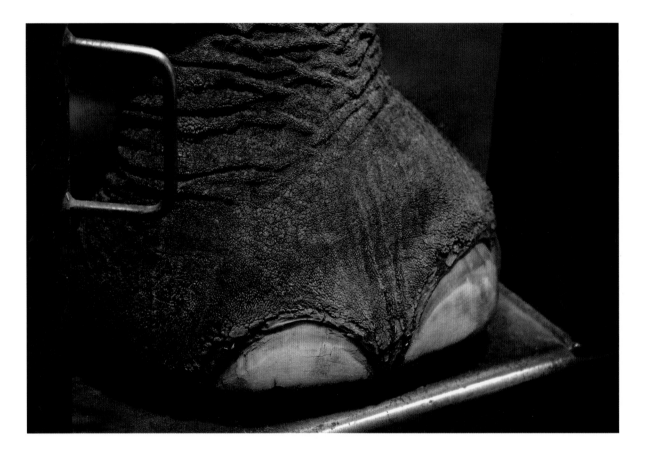

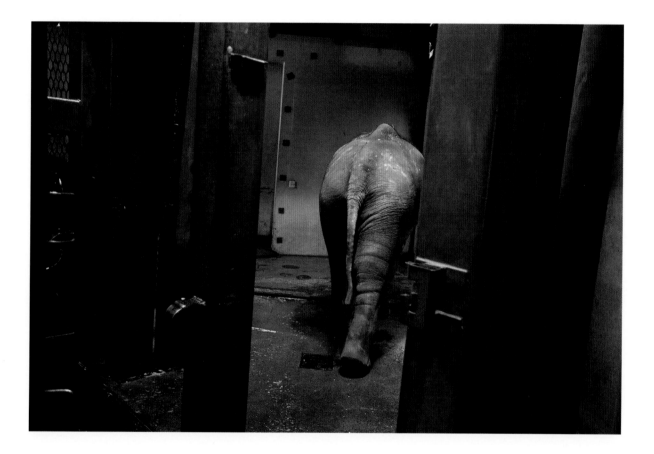

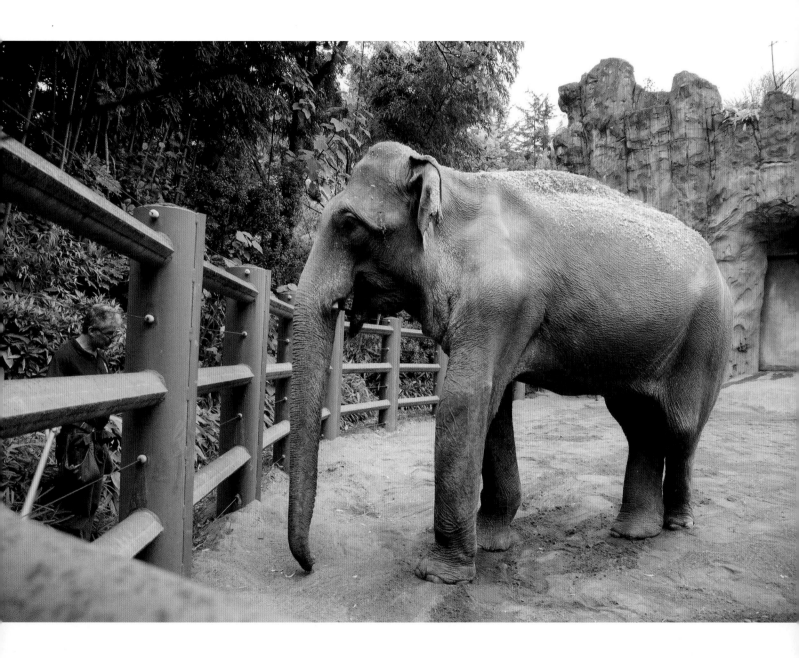

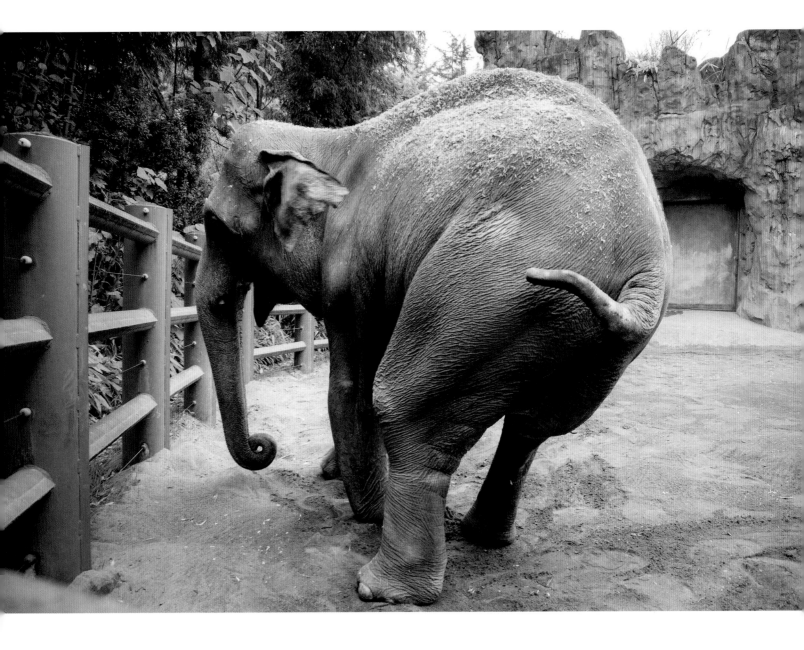

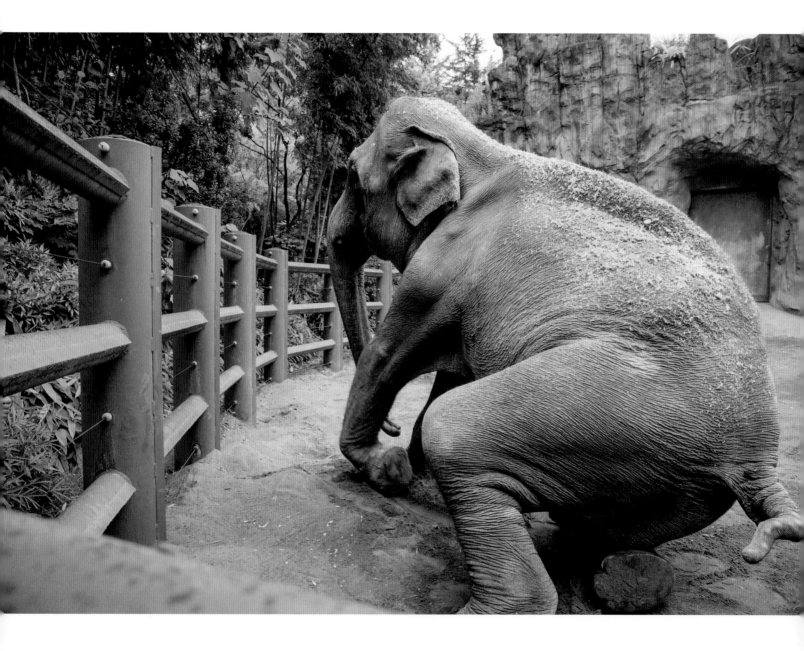

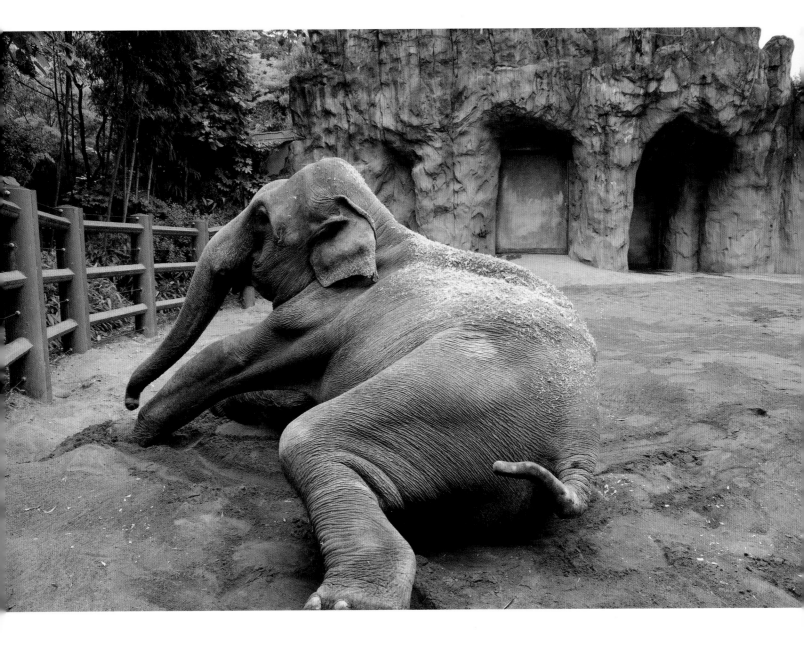

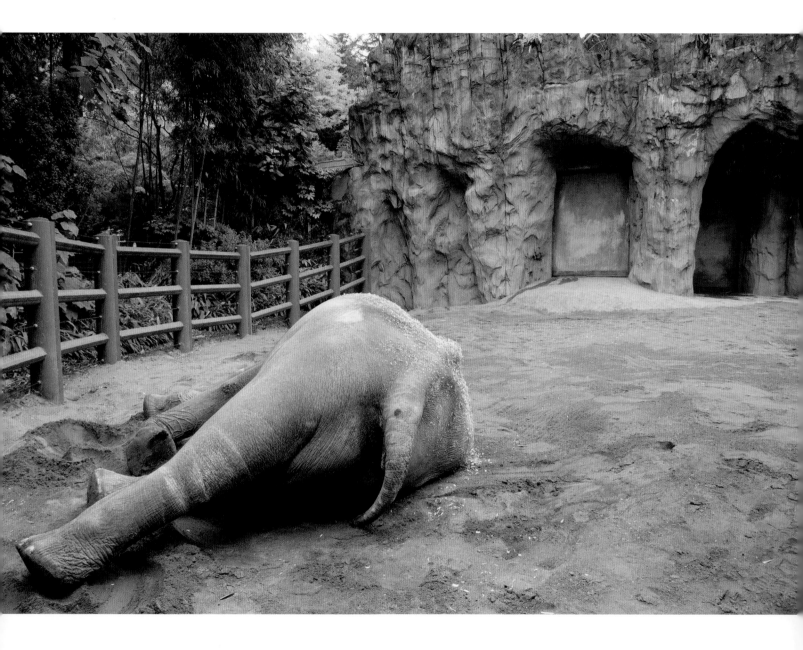

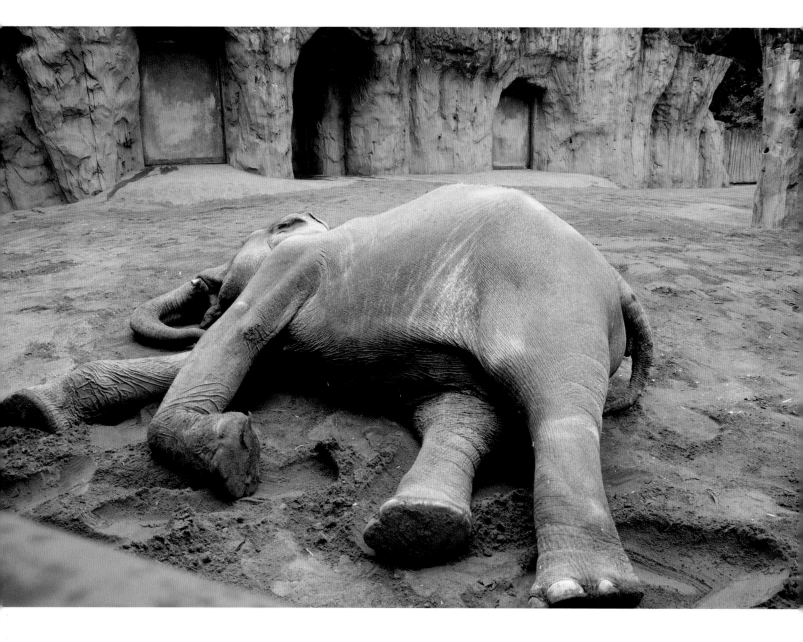

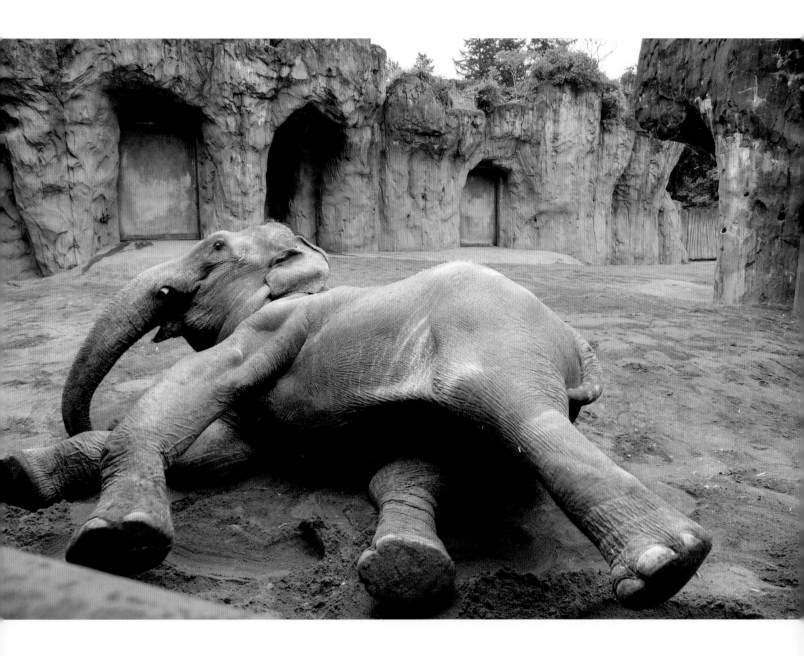

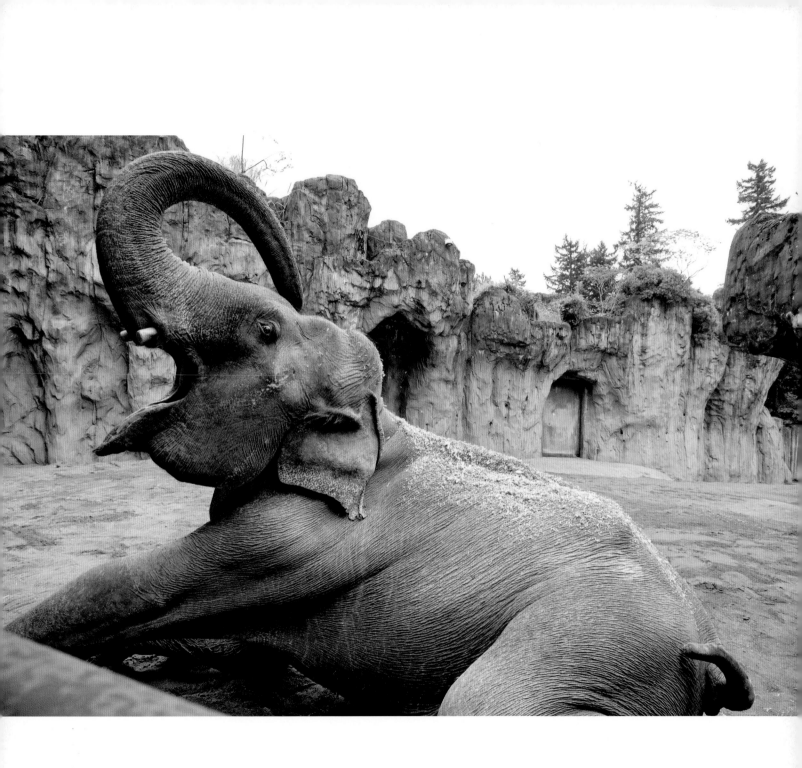

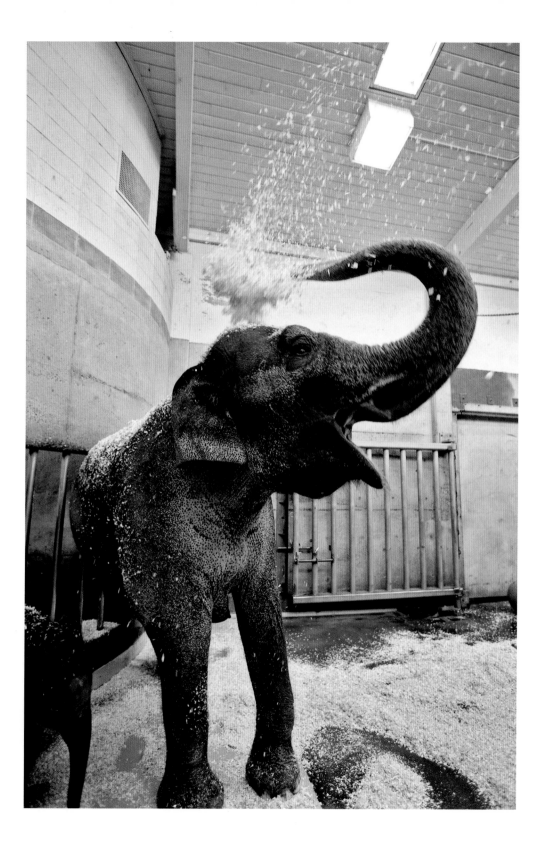

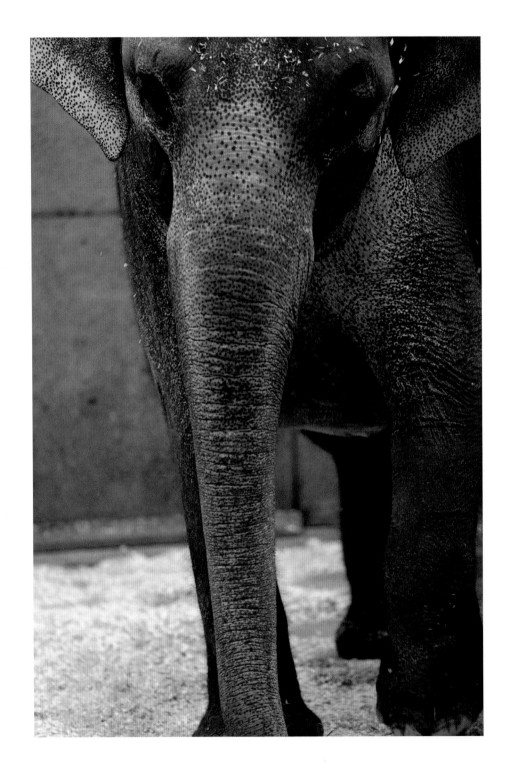

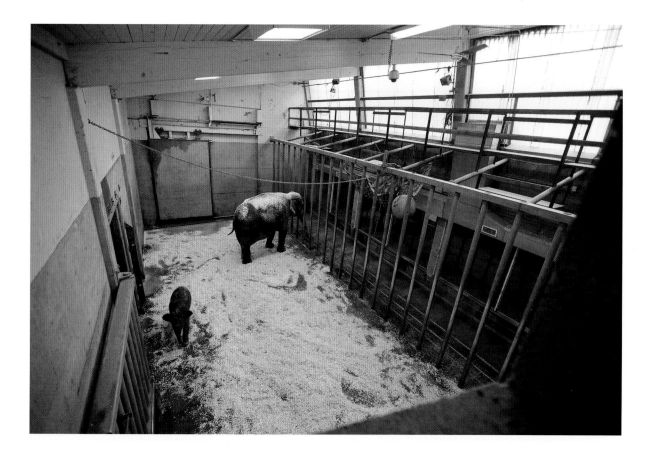

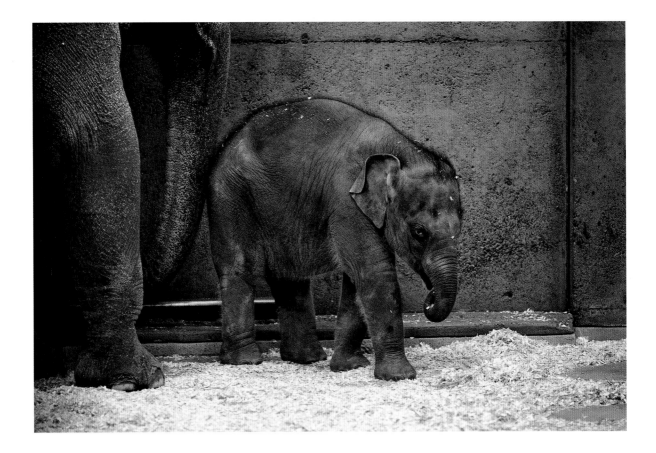

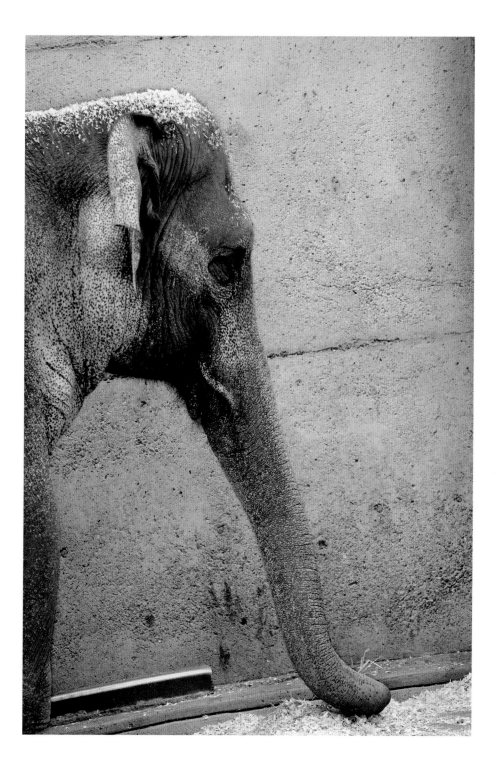

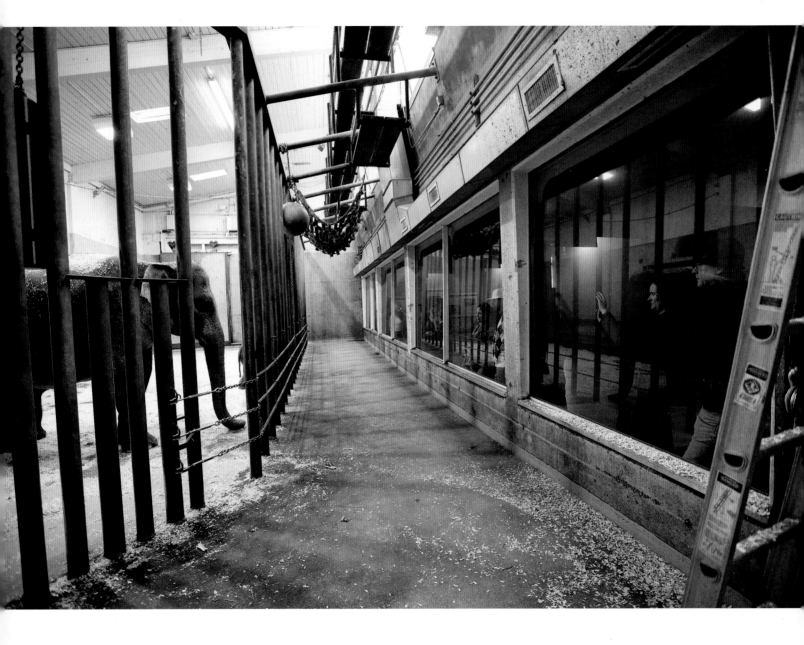

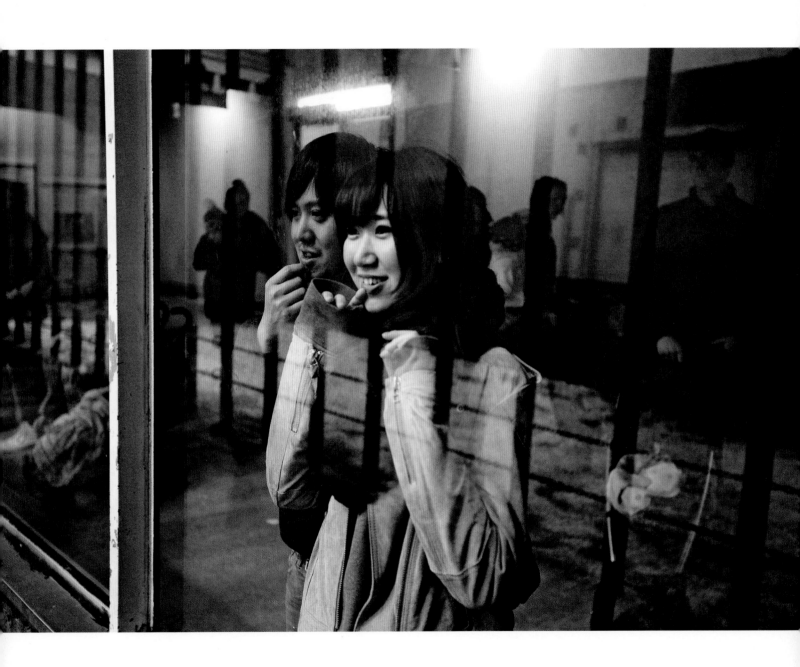

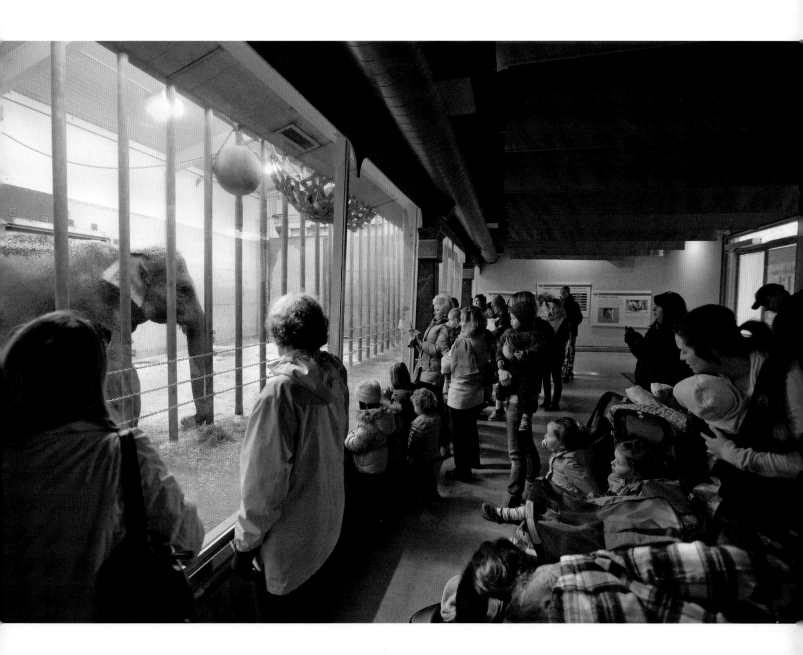

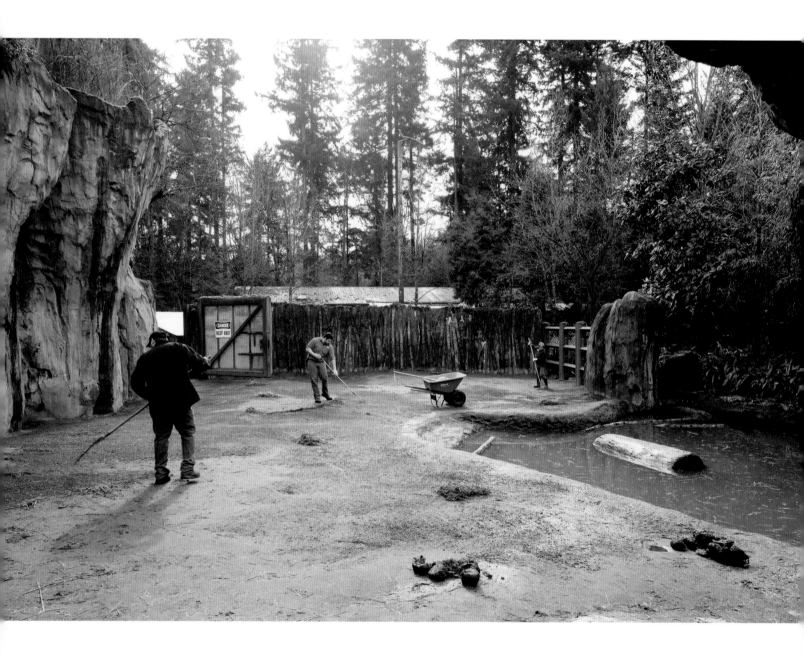

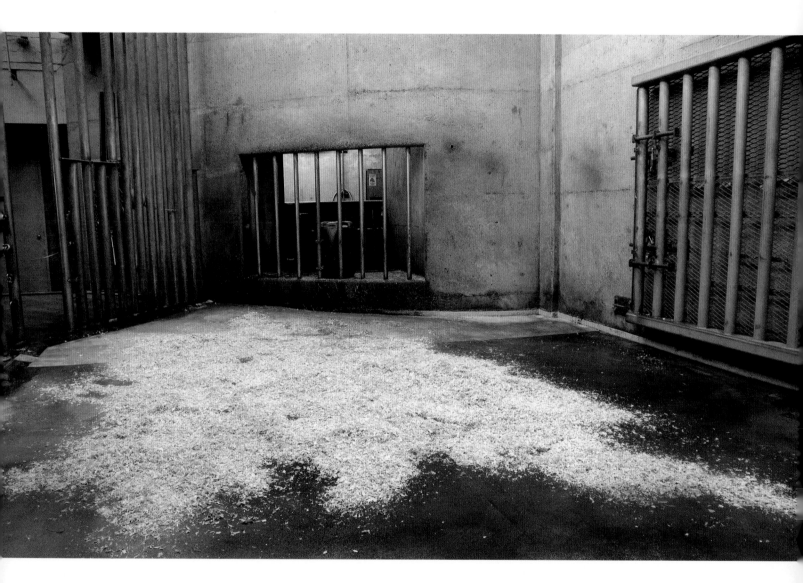

[list of photographs]

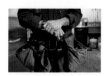

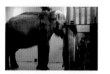

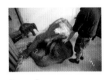
[p. 35]
Lily and Rose-Tu, Shawn with carrot

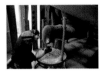
[p. 36]
Pedicure (Dimas and Tusko)

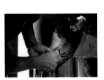
[p. 37]
Dimas grooming Tusko with hook knife

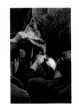
[p. 38]
Vet

[p. 39]
Squeeze chute and keepers' service area

[p. 40]
Rama exiting squeeze chute

[p. 41]
Mike Keele in keepers' service area

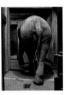
[p. 42]
Rose-Tu with sawdust

[p. 43]
Tail

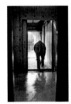
[p. 45]
West gate

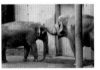
[p. 46]
Sung-Surin and Tusko

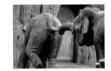
[p. 47]
Samudra and Chendra

[p. 48]
"Rama, blow!"

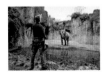
[p. 49]
Jeb trains Rama

[p. 50]
Elephants in back yard

[p. 51]
Viewing area

list of photographs

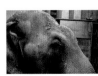

[p. 53]
Rama in profile

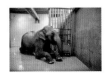

[p. 55]
Packy in profile

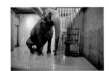

[p. 56]
"Stretch, Packy!"

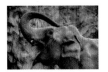

[p. 57]
Packy lying down

[p. 58]
Rose-Tu and Lily from rear

[p. 59]
Rose-Tu and Samudra

[p. 60]
Ear

[p. 61]
Temporal gland secretion

[p. 62]
Foot

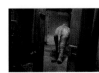

[p. 63]
Rama leaving squeeze chute

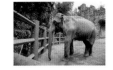

[p. 65]
Rama exercising 1

[p. 66]
Rama exercising 2

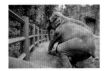

[p. 67]
Rama exercising 3

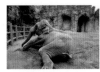

[p. 68]
Rama exercising 4

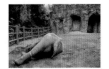

[p. 69]
Rama exercising 5

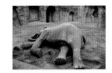

[p. 70]
Rama exercising 6

 [p. 71]
Rama exercising 7

 [p. 73]
Rama trunk up

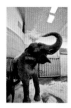 [p. 75]
Rose-Tu throwing sawdust

 [p. 76]
Rose-Tu advancing

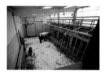 [p. 77]
Rose-Tu and Lily in front room

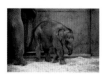 [p. 78]
Lily (Rose-Tu)

 [p. 79]
Rose-Tu in profile

 [p. 80]
Rose-Tu on display

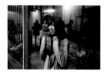 [p. 83]
Spectators

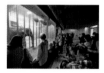 [p. 85]
Visitor viewing area

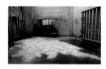 [p. 86]
Servicing the exhibit

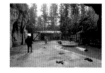 [p. 89]
Fresh sawdust, front room

 [p. 97]
Rose-Tu, Samudra, Dimas, and Jeb

[acknowledgments]

First and foremost, my very deep gratitude to Nigel Rothfels, who made this project happen—and in many more ways than one. With his delighted enthusiasm for art as its own way of knowing, I could ask for no better companion than Nigel to explore so compelling and complicated a subject. I also want to thank the keepers, Mike and Bob, Jeb and Dimas, Shawn, Pam, and Trina, who allowed me into their world, who took care of me while I was there. Then there is Tom Bamberger, whom I thank for the beauty of these prints, not to speak of their edit. Finally, there are my closest readers: Jane Gallop, Steven Feld, David Greenberger, Tom Knechtel, Mark Lapin, and Luis Roldan. Thank you thank you all.

DICK BLAU

I thank Dick Blau for a remarkable experience in genuine collaboration. Thanks, too, to Kim Smith, Stephanie Cameron, Bob Lee, and especially Mike Keele for making the project possible and continuing to support the work over the long term. I also wish to express my gratitude to the many people I have met over the years, including those in this book, who are dedicated to improving the lives of the elephants in their care and who have shared their thoughts with me. Financial support for this project was provided by the University of Wisconsin–Milwaukee's Office of the Provost and Office of Research. Finally, I thank Kendra Boileau, editor-in-chief at Penn State Press, and Garry Marvin, coeditor of Animalibus: Of Animals and Cultures, for their support and enthusiasm.

NIGEL ROTHFELS

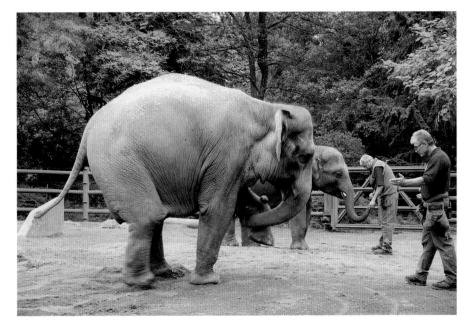

Typeset by
REGINA STARACE

Printed and bound by
OCEANIC GRAPHIC
INTERNATIONAL

Composed in
CHAPARRAL PRO

Printed on
KINMARI MATT

Bound in
RAINBOW CAPE COD